Remembering Pensacola

Jacquelyn Tracy Wilson

TURNER
PUBLISHING COMPANY

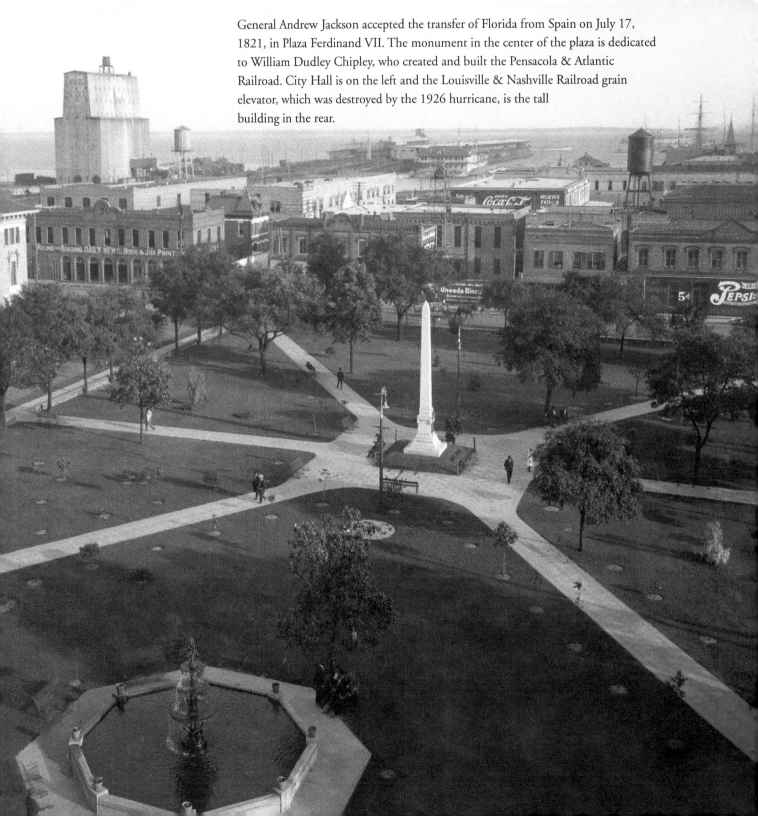

General Andrew Jackson accepted the transfer of Florida from Spain on July 17, 1821, in Plaza Ferdinand VII. The monument in the center of the plaza is dedicated to William Dudley Chipley, who created and built the Pensacola & Atlantic Railroad. City Hall is on the left and the Louisville & Nashville Railroad grain elevator, which was destroyed by the 1926 hurricane, is the tall building in the rear.

Remembering
Pensacola

Turner Publishing Company
www.turnerpublishing.com

Remembering Pensacola

Copyright © 2017, 2010 Turner Publishing Company

Library of Congress Control Number: 2010924327

ISBN: 978-1-59652-673-0

Printed in the United States of America

ISBN: 978-1-68336-872-4 (pbk.)

CONTENTS

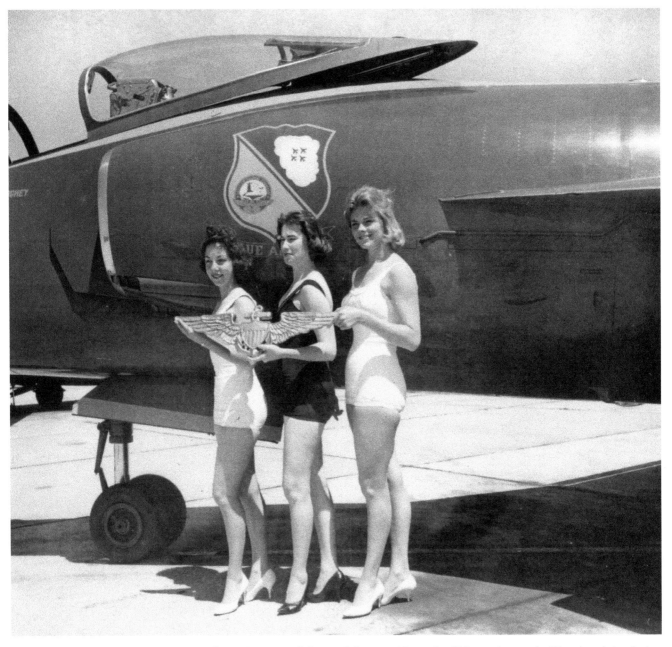

Margaret Wilkinson, Mary Turner, and Joan Simmons (left to right) pose with a pair of Navy wings and a Blue Angels jet during the Naval Aviation 50th anniversary celebrations at Pensacola in 1961.

ACKNOWLEDGMENTS

This volume, *Remembering Pensacola,* is the result of the cooperation and efforts of many individuals and organizations. It is with great thanks that we acknowledge the State Archives of Florida for their generous support.

As author, I would like to thank the Pensacola Historical Society for the use of their excellent research materials. Mr. David P. Ogden, historian and ranger for the Gulf Islands National Seashore, was an invaluable source for information about Fort Barrancas and the Navy Yard. Lieutenant Commander Donald T. McCloskey, USN (retired), offered me his vast knowledge of naval aircraft. The information they freely shared with me improved this book immensely.

PREFACE

Others have written wonderful books full of photos of Pensacola's past. I hope that my effort will be accepted for what it is intended to be, an addition to the story of the growth and development of a Southern city with a special place in history. As a native and lifelong resident of the greater Pensacola area, I hope that my personal knowledge and love of Pensacola has helped to add just that little something that may have been overlooked by others.

Photographs help to bring the past to life in a way that words alone cannot accomplish. They help the viewer understand a way of life that is foreign to them. Images capture moments of time, freezing minute details that may be overlooked elsewhere, aspects of the past that would otherwise be lost in the passage of time. Photographs also help cement our connections with the past. As a historian, I believe that we cannot understand the present without knowing the past that has shaped our environment. As an artist, I know that the visual can make a powerful, lasting impact on the viewer. Photographs are a wonderful aid for adding to our knowledge.

With the exception of touching up imperfections that have accrued with the passage of time and cropping where necessary, no changes have been made. The focus and clarity of many images are limited to the technology and the ability of the photographer at the time they were recorded.

Pensacola has a long history filled with triumph and with tragedy. The photographs presented here capture some of these moments. The story begins with scenes of Confederate troops defending Fort Barrancas, which was recaptured by Union forces after the Confederate withdrawal from the city. Scenes of

the bustling port city are followed by the stark images of a city almost totally destroyed by fire in December 1880. Throughout the book's pages are scenes from everyday life—triumphal parades, disasters, and people at play. And Pensacola's military bases, so important to the city, receive special focus. I hope you will enjoy these photographs and appreciate the full range of emotions many of them can evoke. Gaze amused at some of the dress styles, take pride in the city's accomplishments, understand the pain inflicted by wars. You will have the privilege of watching Pensacola grow and mature as you travel through these pages.

I wish that I could tell a much broader story than the one in this book, because Pensacola has so many stories to offer, but the scope of any single book must always be limited. Much of this book concentrates on the old core of Pensacola, the area found within the confines of Pensacola Bay, North Hill, Florida Blanca Street, and DeVilliers Street. Of course, no history of Pensacola is complete without a look at the Navy bases, the forts, and Pensacola Beach. As I look at old photographs, I want to know the story that was captured when the shutter clicked and the scene was burned onto film. With the use of newspaper clippings, city directories, conversations with knowledgeable people, and information in the archives of the Pensacola Historical Society, I have tried to find some of the stories hidden in these images. I hope you enjoy these stories as much as I do.

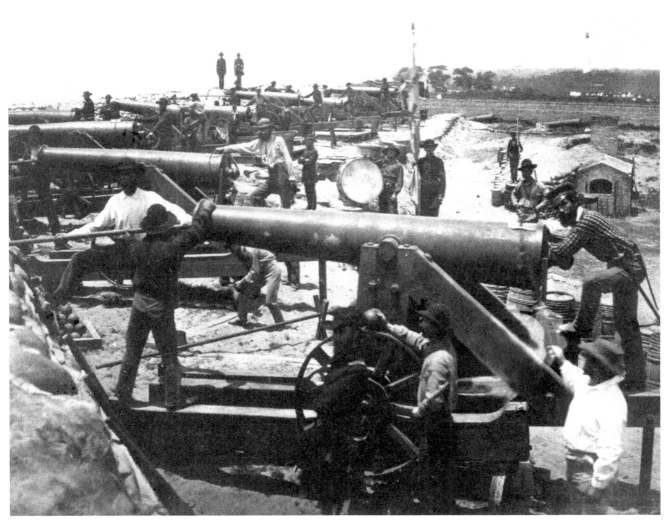

Confederate troops occupied Fort Barrancas from January 12, 1861, until they withdrew from Pensacola on May 10, 1862. These cannon overlooked the mouth of Pensacola Bay, controlling access to Pensacola's port. The shot furnace is in the upper-right corner of the photograph.

A City of Firsts

(1861–1899)

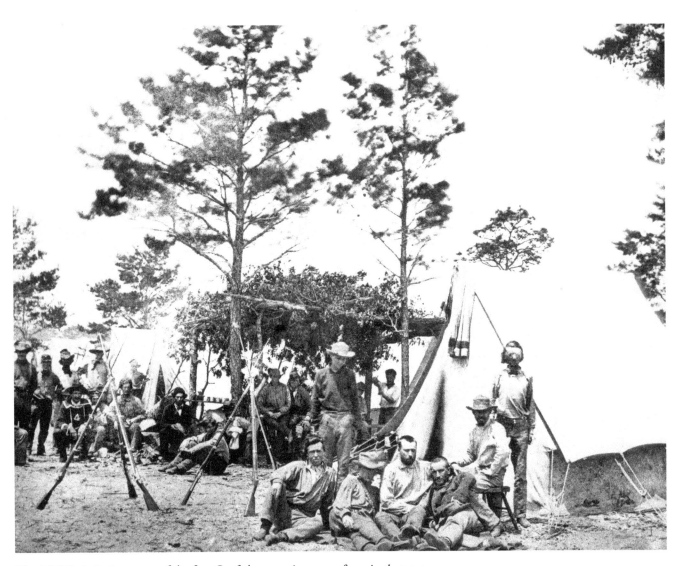

The 9th Mississippi was one of the first Confederate regiments to form in that state. They marched into Pensacola in April 1861 and camped near Fort Barrancas.

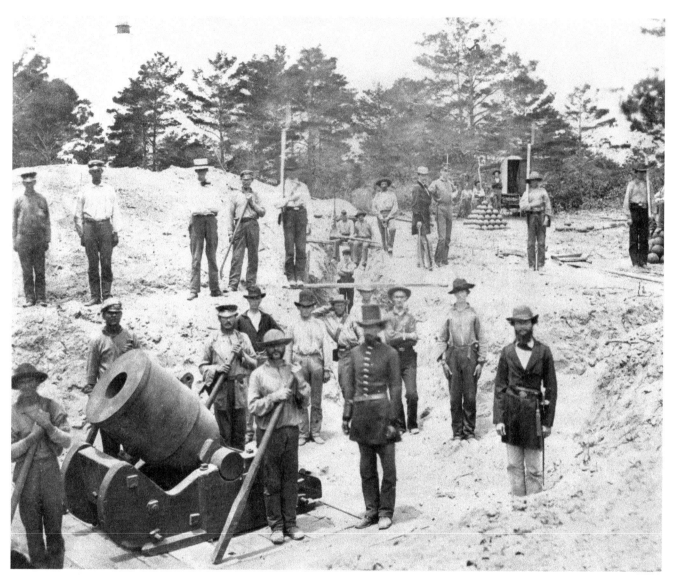

Along with cannons, Confederate soldiers used mortars to defend Fort Barrancas. Used to lob shells over walls and other obstacles, the mortar's range was controlled by the amount of gunpowder used with the round.

The original mission of ships stationed at the Pensacola Navy Yard was to patrol the Gulf of Mexico and the Caribbean to intercept pirates and slave ships. Some of the cannon used for defense of the yard are displayed in 1865. The steam engineering department, machine shop, and hospital are visible at the rear of the photograph.

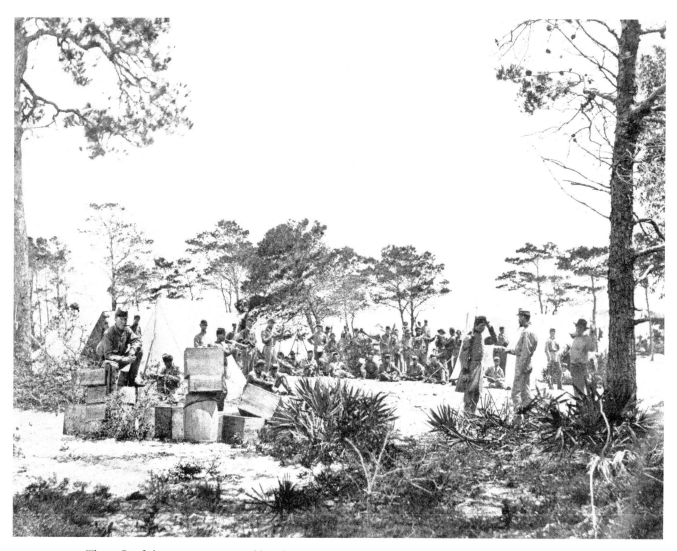

These Confederate troops camped beside Bayou Grande may be members of Company A of the Orleans Cadets, the first Confederate volunteer force to form in Louisiana. The Orleans Cadets organized on April 11, 1861, the day after Confederate troops demanded the surrender of Union forces at Fort Sumter, South Carolina.

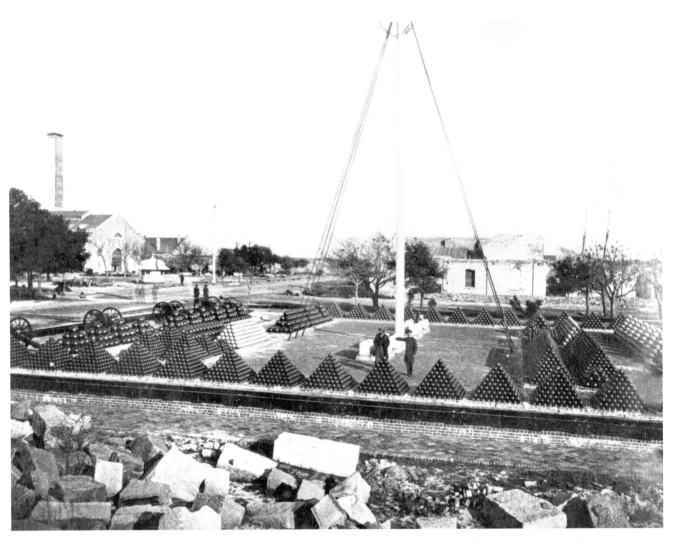

Stacked for storage, these cannon balls form sculptural displays at the Navy Yard in 1865. A ship's mast stands in the center of the display, and the steam-engineering department is at upper-left.

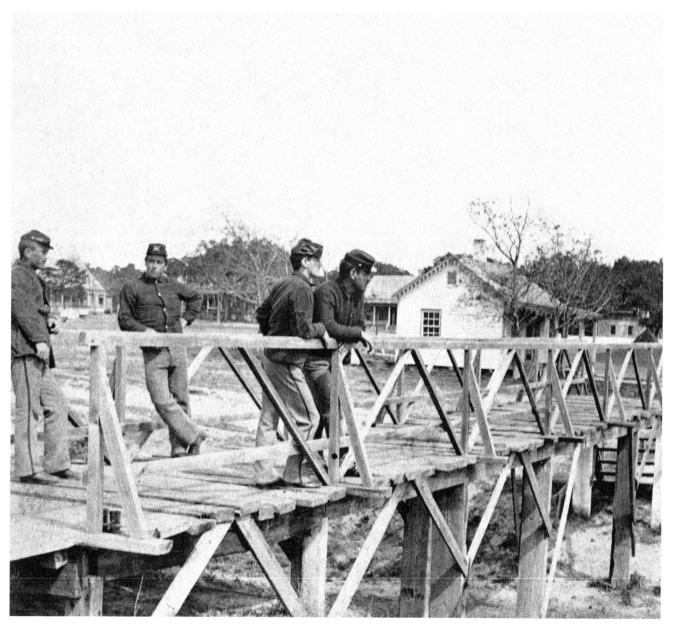

Union troops reclaimed the Pensacola military facilities after they were abandoned by the Confederacy in 1862. This view shows post–Civil War troops at leisure at Fort Barrancas in 1870.

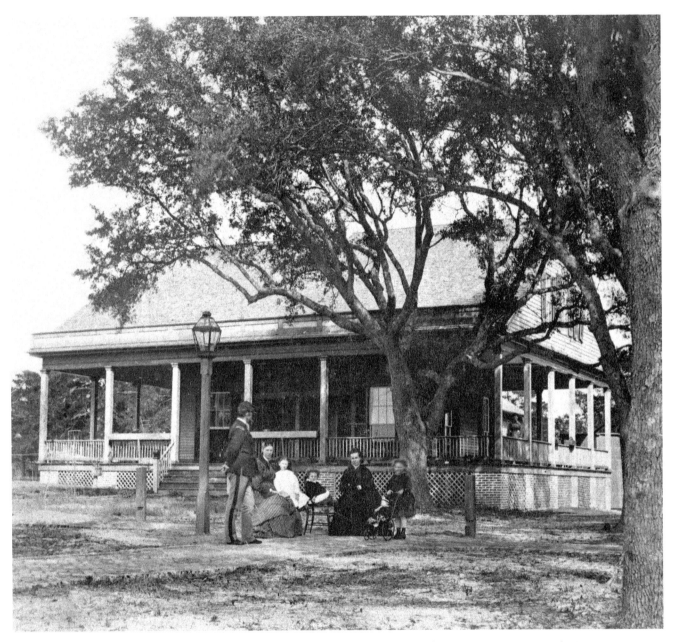

This spacious base housing was home to Captain Van Andress while he was stationed at Fort Barrancas around 1870. The deep porches and long windows helped to cool the home during hot, humid summers, and the latticework along the foundation helped to prevent wildlife from taking up residence under the house.

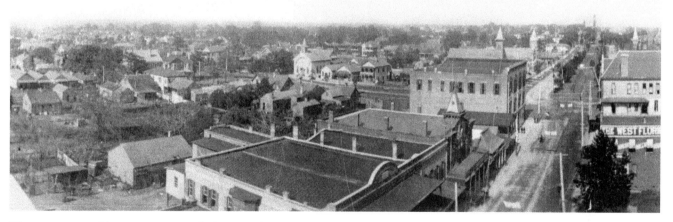

This 1871 view of downtown Pensacola faces northwest over the Pensacola skyline. The Masonic Temple is at upper-right and the steeples of the Methodist Episcopal Church and St. Michael's Catholic Church rise over North Palafox. The German Lutheran Church, at Garden and Baylen streets, is visible near the center of the picture. Most of the buildings on the west side of South Palafox were destroyed in the fire of 1880.

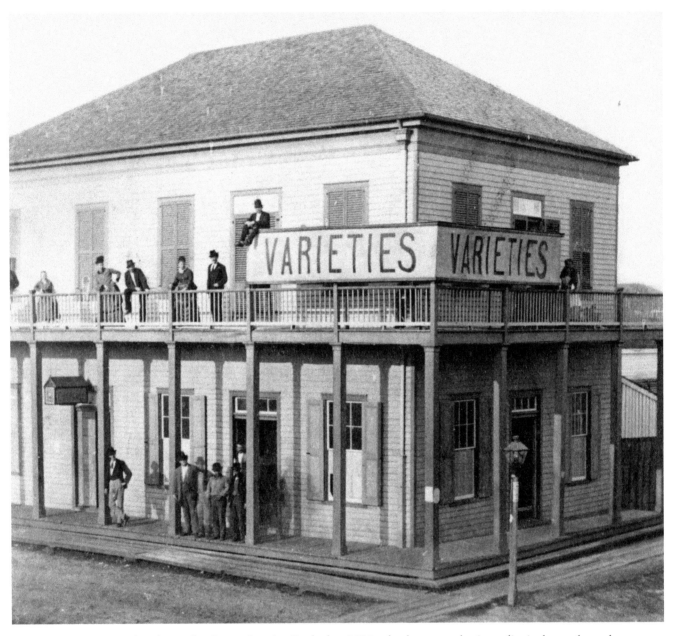

This variety store catered to the needs of a growing city. By the late 1800s, the downtown business district boasted wooden sidewalks and streetlights. The second story of buildings like this one often served as home for the business owner and his family.

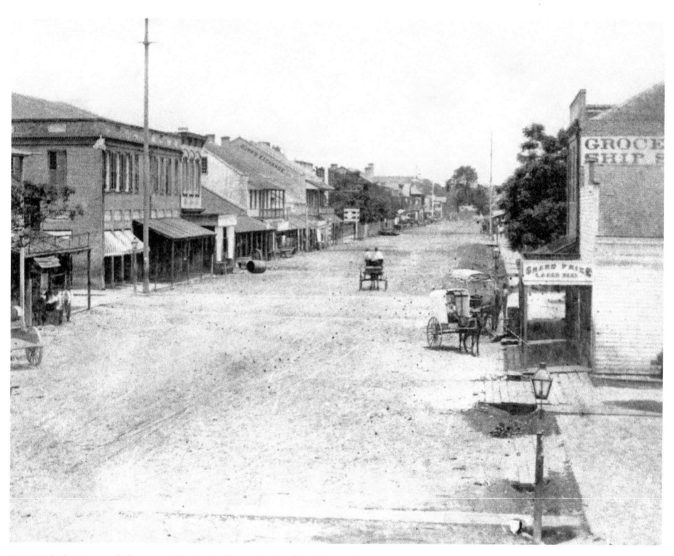

By 1876, the Pensacola business district had streetlights, but the roads remained unpaved. The sign on the store at right reflects the city's strong ties with its harbor and the ships that docked there.

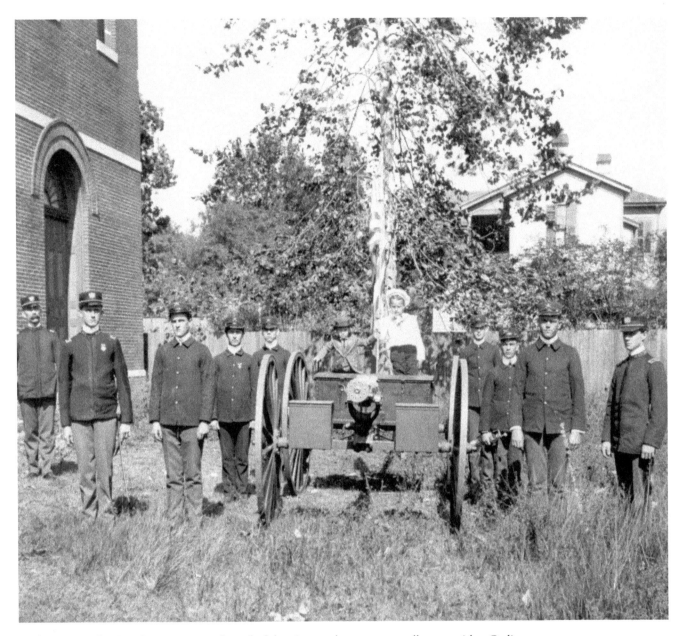

Cadets stationed at Fort Barrancas near the end of the nineteenth century proudly pose with a Gatling gun. The fort is also famous for housing some of the Chiricahua Apache tribe, including Chief Geronimo, for 18 months from 1886 until 1888.

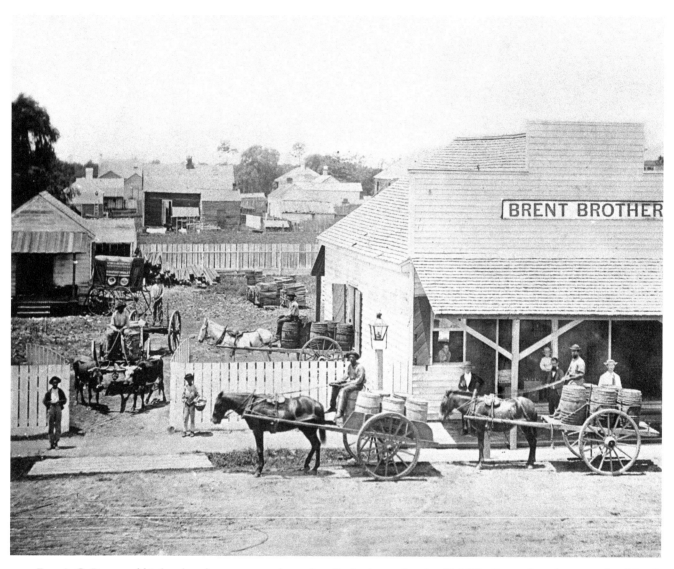

Francis C. Brent and his brothers began a general merchandise business after the Civil War. Located on the west side of South Palafox between Garden and Romana streets, the store's inventory included provisions, liquors, wines, and local produce. Francis later became president of the First National Bank, as well as president of the Pensacola Lumber Company.

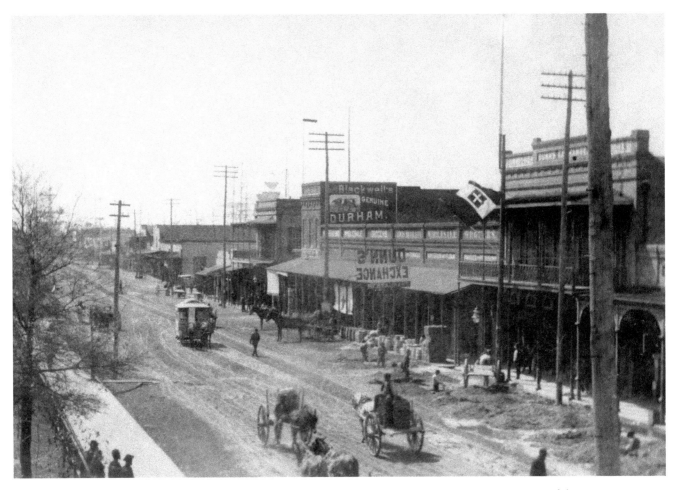

Pensacola rebuilt quickly after the 1880 fire. Dunn's Exchange, a restaurant owned by John Dunn, was one of the businesses destroyed in the fire. His new restaurant was located at 517-519 South Palafox.

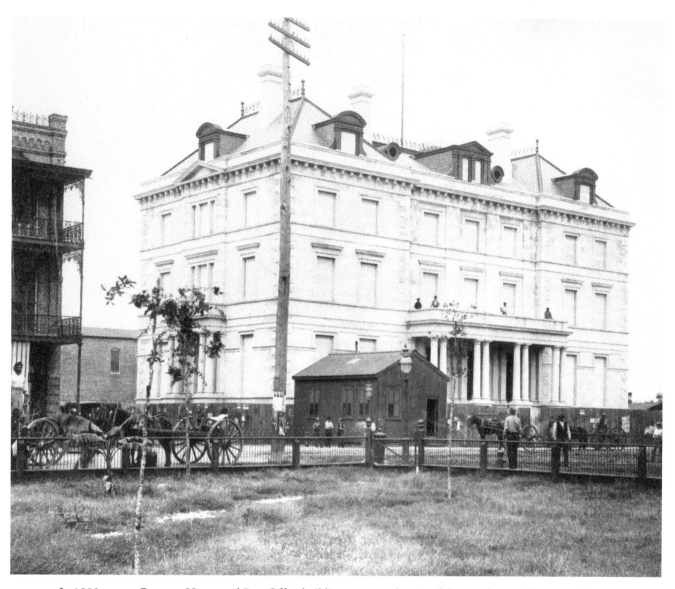

In 1883, a new Customs House and Post Office building arose on the site of the one destroyed in 1880. The Renaissance Revival–style building also contained offices for the district attorney and the district and circuit courts. In 1940, Escambia County accepted the building from the federal government and converted it into a county courthouse. County offices have now moved to a new building, and the interior of the old courthouse is being restored to its original grandeur.

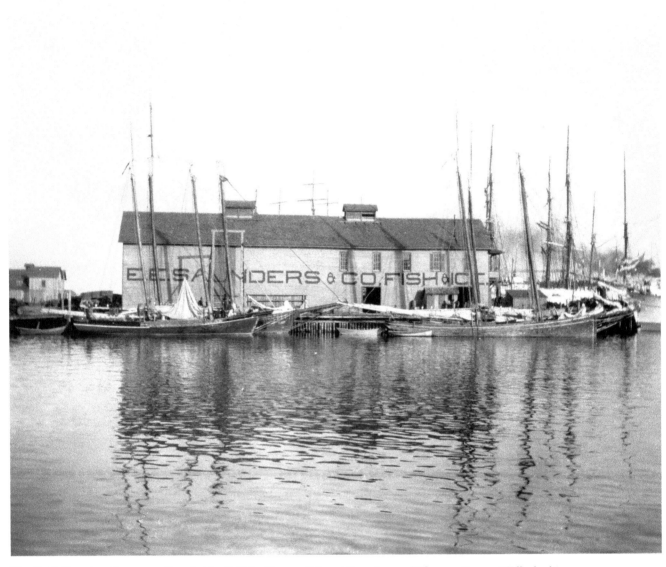

The E. E. Saunders Company, founded in 1883 by Eugene Edward Saunders and Thomas Everett Wells, had its own ice plant and cold storage facility. The many railroads that served Pensacola helped the E. E. Saunders Company to become the world's largest wholesaler of red snapper.

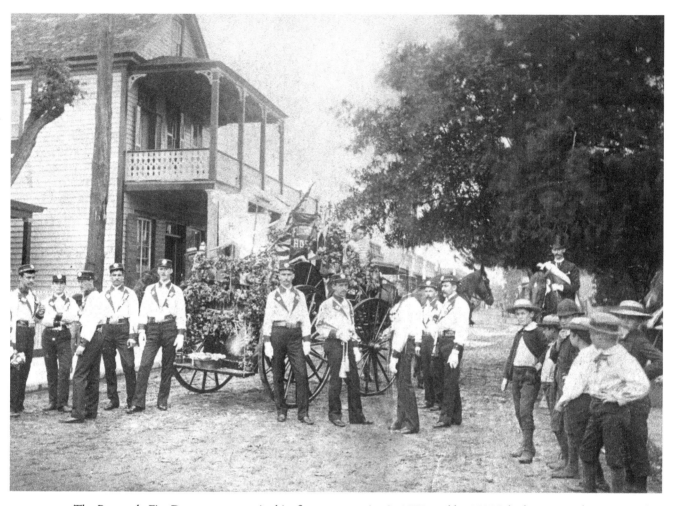

The Pensacola Fire Department acquired its first steam engine in 1878, and by 1893 it had grown to three companies. Station Number 1 was the Germania Hose Company on East Zarragossa, where the Quayside Art Gallery is now located. Number 2, the Florida Hose Company, was located on East Garden near the intersection of Jefferson. Company Number 3, the Washington Hose Company, was on West Zarragossa near Palafox Street.

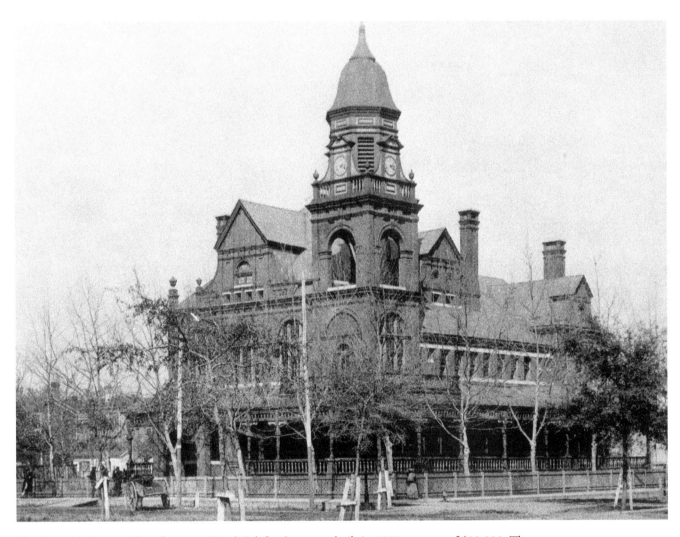

The Escambia County Courthouse on North Palafox Street was built in 1883 at a cost of $32,000. The Armory, home of the 3rd Battalion Florida State Troops, was just north of the courthouse.

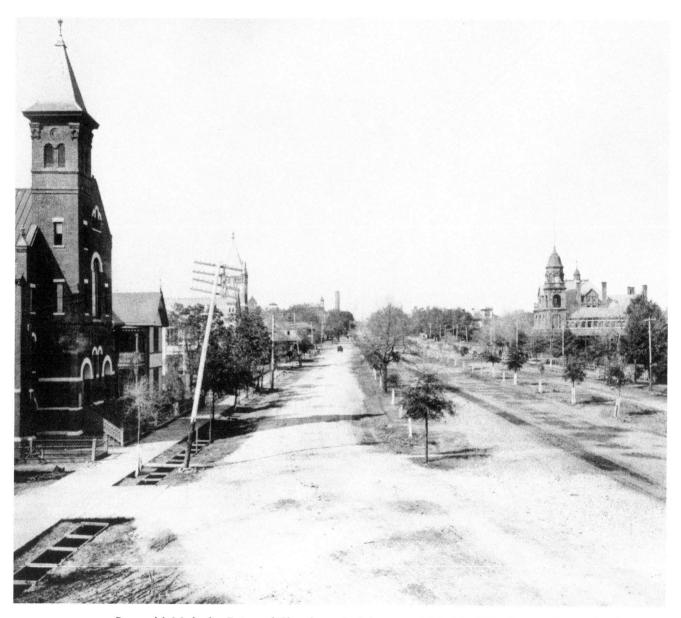

Pensacola's Methodist Episcopal Church, on the left, was established in 1821. Construction on this three-story Romanesque Revival building began in 1881 and the first services were held in 1884, although the building was not completed until 1890. The building was sold in 1909, and the Hotel San Carlos was built on this site.

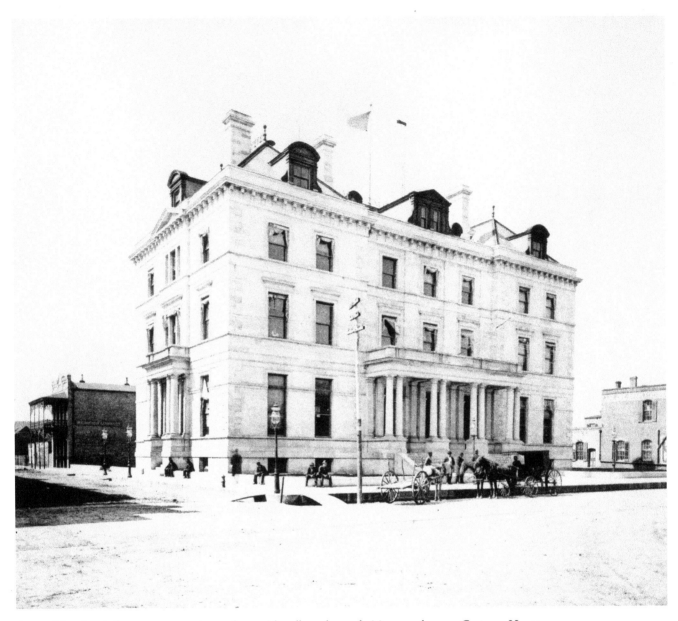

A paved South Palafox, streetcar service, and new sidewalks welcomed visitors to the new Customs House and Post Office. The short wall around the building provided a convenient place for people to sit while they waited for appointments.

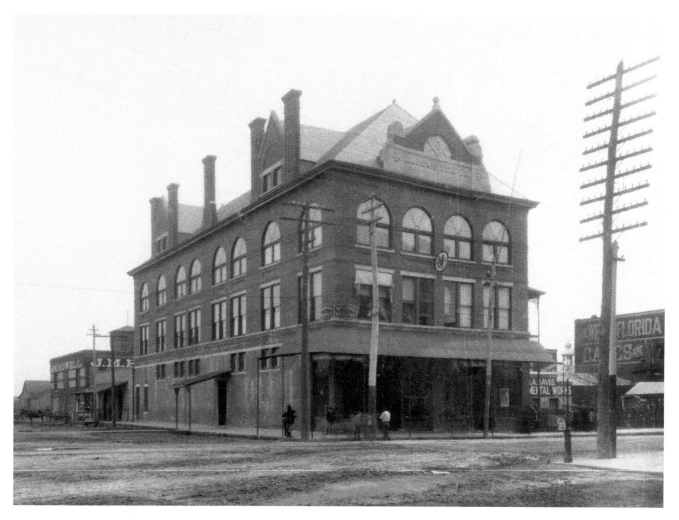

Erected around the turn of the century, this building was the home of the Masons for one hundred years, replacing their former lodge on East Zarragossa Street. The meeting rooms were on the third floor, and the first and second floors were rented for professional offices and retail space. In 2000, the Masons moved to a new building on Longleaf Drive.

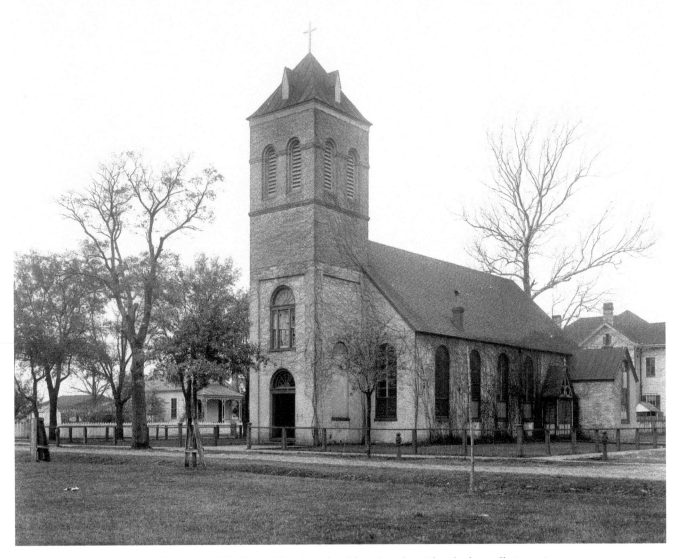

Begun in 1830 and completed in 1832, Old Christ Church is the oldest church in Florida that still sits on its original foundation. Services were held in this building until 1903, when the growing parish moved to their newly built church at the corner of North Palafox and Wright streets. During the Civil War, Union troops used the church building as a jail, hospital, and barracks. The building served as Pensacola's first public library and was home to the Pensacola Historical Society.

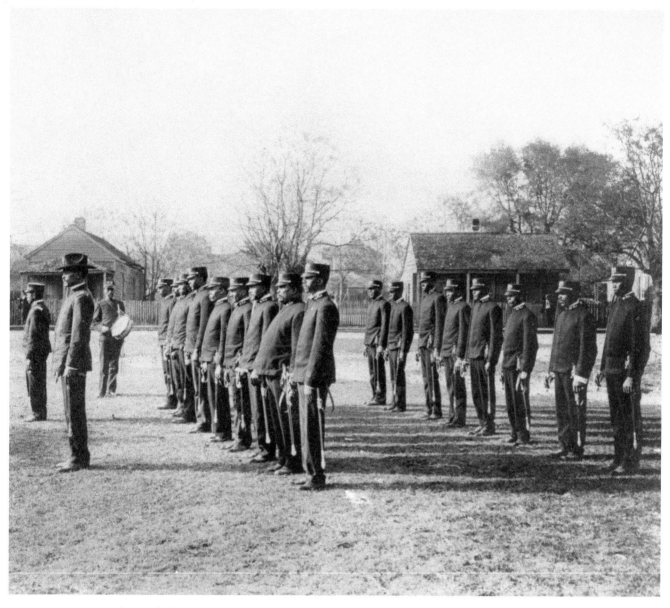

The Garfield Guards, based in Pensacola, was an African-American unit of the Florida State Volunteer Militia.

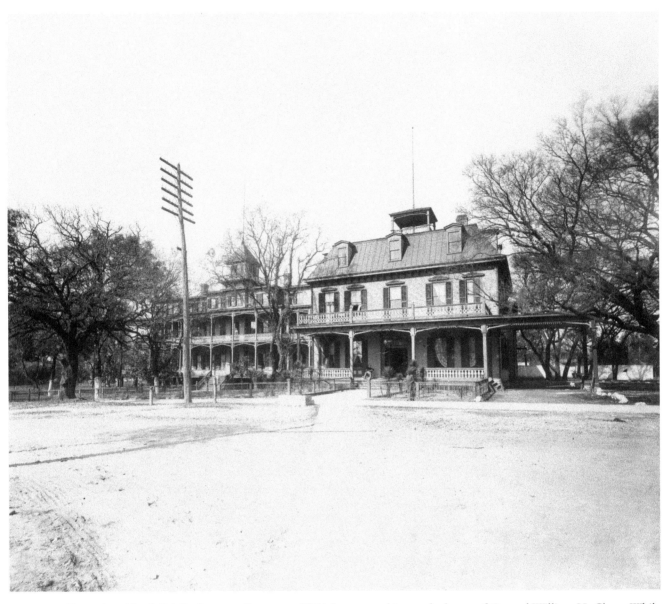

Situated on North Palafox between Gregory and Wright streets, this was the home of General William H. Chase. While serving with the U.S. Army, General Chase oversaw construction of Fort Barrancas. When the South seceded, Chase resigned his commission and joined the Confederacy. By 1898, the home had become the Escambia Hotel.

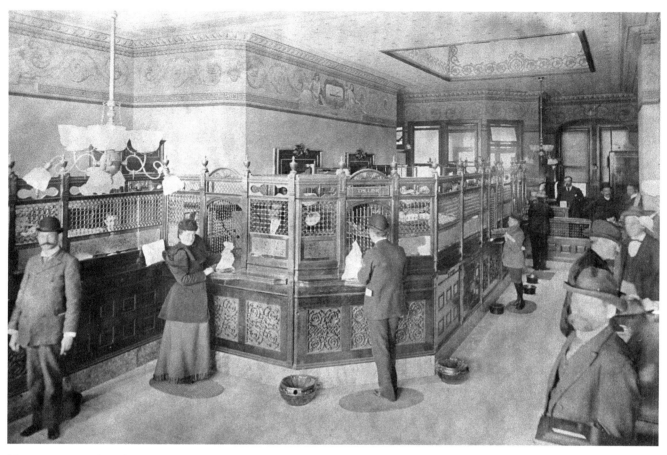

The First National Bank, at 213 South Palafox, was organized in 1880. The building housed the Citizens and Peoples Bank for 80 years and now serves as offices for the Escambia County Tax Collector.

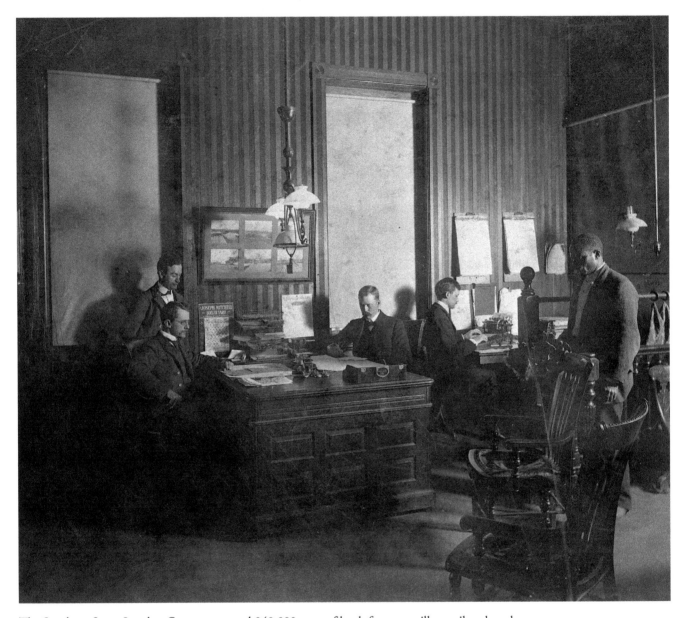

The Southern States Lumber Company owned 340,000 acres of land, four sawmills, a railroad, and a steamship. Pictured in the company office on South Palafox, Mr. Frazier F. Bingham, the assistant manager, sits at his desk third from left.

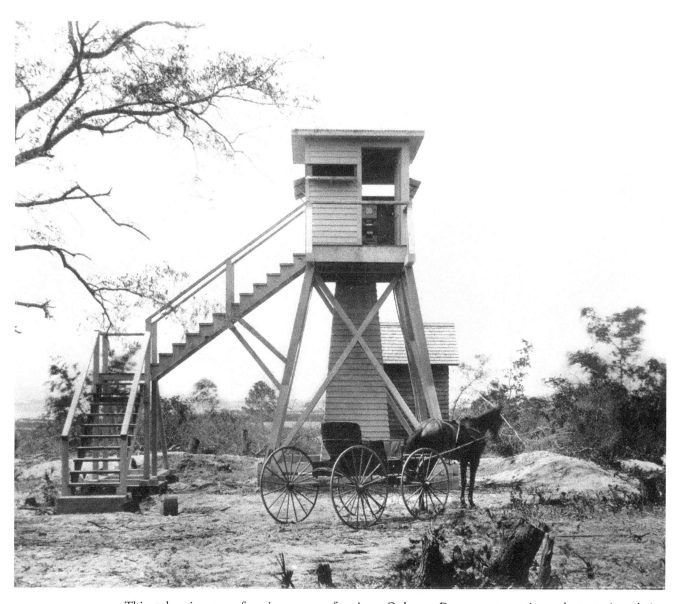

This end station, one of a pair, was part of an Army Ordnance Department experimental target triangulation system established in Pensacola. The pair of stations, outfitted with a telephone, a time interval bell, and an azimuth scope, were used to identify the firing range of distant, moving targets. The firing calculations were phoned to a series of connected buildings that housed the battery commanders and the fire commander. The network became known as the Barrancas System.

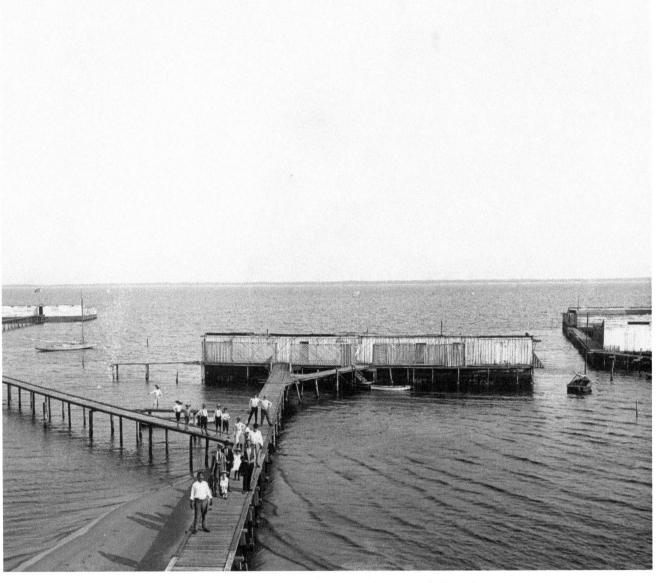

Built at the end of Florida Blanca Street, Saccaro's bathhouses and pier, with separate facilities for women and men, offered Pensacolians a place to frolic on hot summer days. The three teenage boys in a group to the left of the main pier were George Earl Hoffman, Sr., a future U.S. District Attorney, Carl Timothy Hoffman, later an attorney and developer, and Vincent Giblin Hoffman.

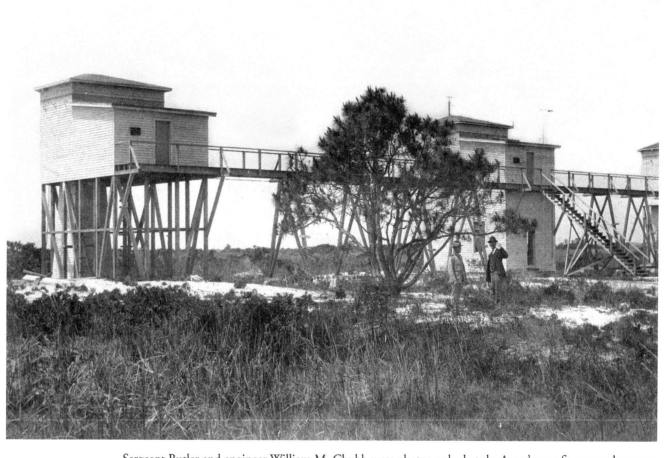

Sergeant Butler and engineer William M. Chubb were photographed at the Army's new fire control system. The system consisted of three battery commander's stations and one fire commander's station. Using calculations supplied by the end stations, this network was able to effectively defend Pensacola.

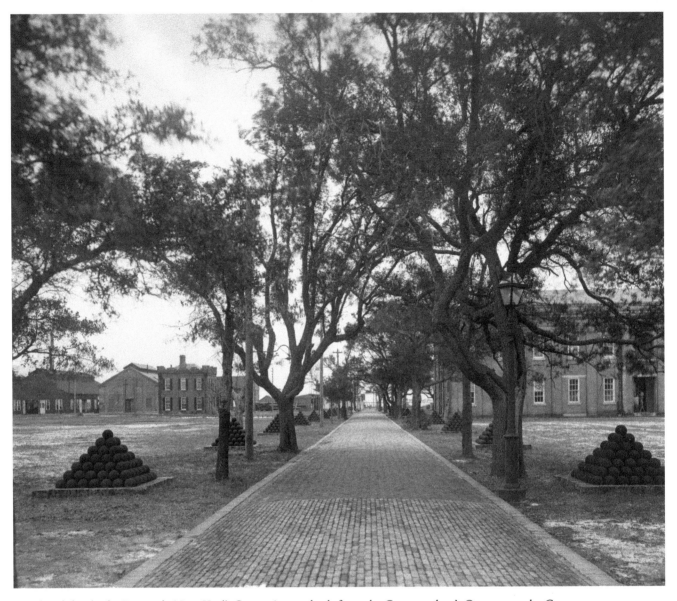

Paved with brick, the Pensacola Navy Yard's Center Avenue leads from the Commandant's Quarters to the Center Wharf. In this 1903 photograph, the administrative building is at right and the chapel is in the building at left.

Resilience amid Hardship

(1900–1919)

Pensacola's deep-water port was a mainstay of the city's economy. The port boasted a grain elevator with a 500,000-bushel capacity, and the timber companies exported live oak, yellow pine, and hickory, along with other woods.

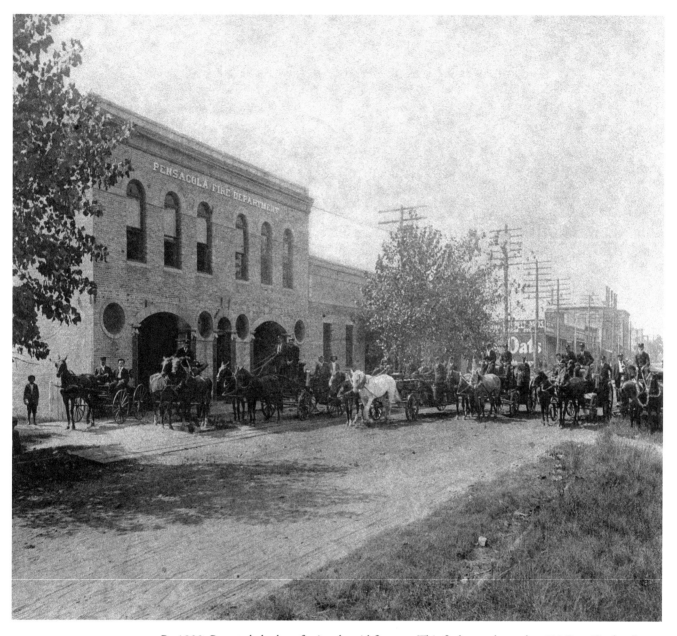

By 1903, Pensacola had professional, paid firemen. This firehouse, located at 109 East Garden Street, housed Company 1, a hook and ladder company, and Company 2, a hose reel company.

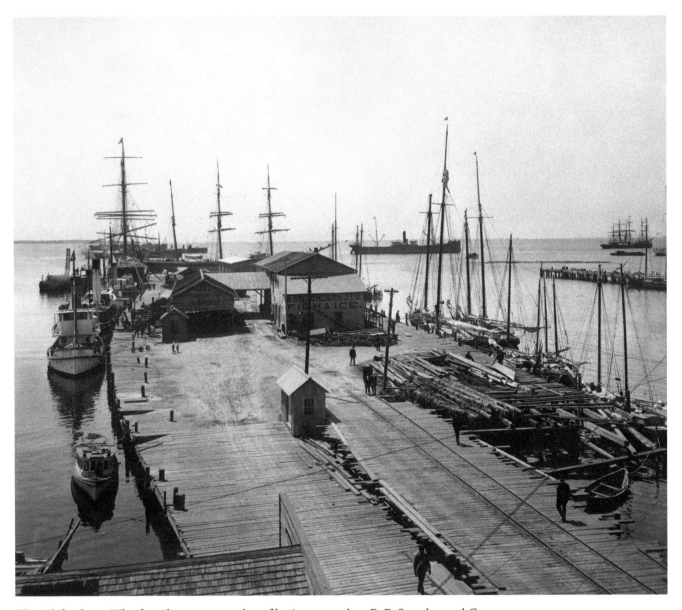

The Palafox Street Wharf was home to a number of businesses, such as E. E. Saunders and Company, in the first building on the right. Other businesses included the Pensacola Fish Company, Gulf Fish Company, U. S. Q. M. Landing, Gulf of Mexico Marine Railroad Company, and the Escambia Fish Company.

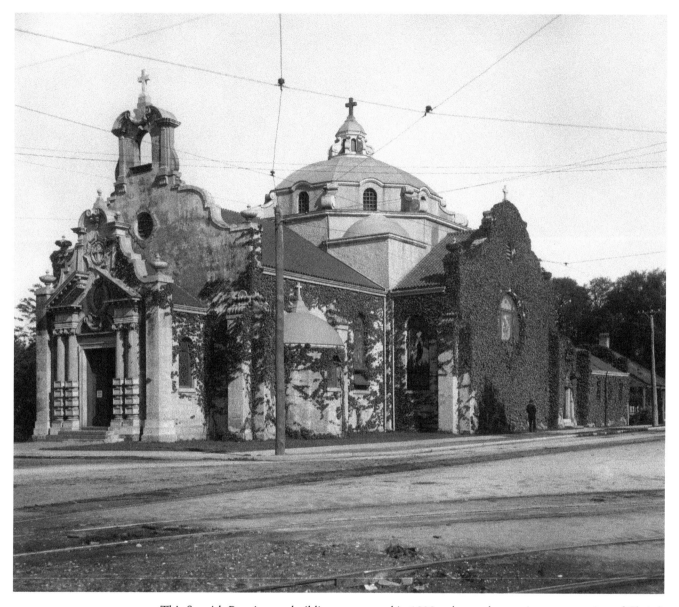

This Spanish Renaissance building was erected in 1903 to house the growing congregation of Christ's Episcopal Church, replacing the building on Seville Square. Designed in the shape of a cross, the church includes a dome that straddles the intersection of the transept and the nave.

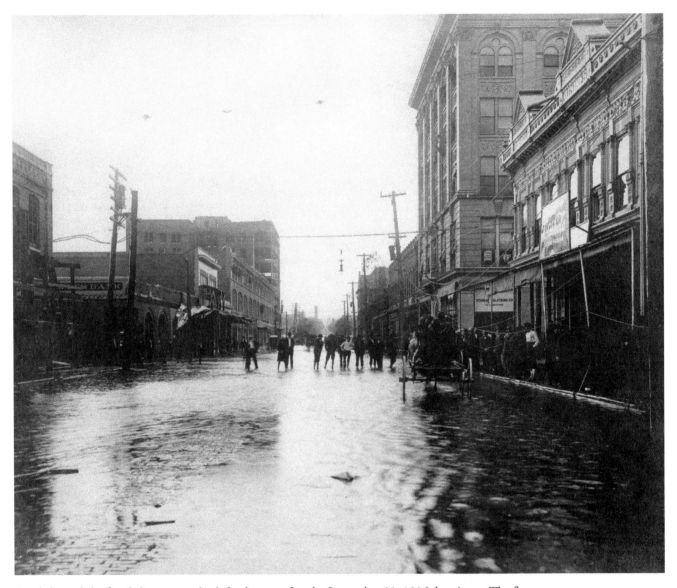

People braved the flooded streets to check for damage after the September 28, 1906, hurricane. The five-story Thiesen Building is on the right, and the seven-story Blount Building is visible in the background, at left.

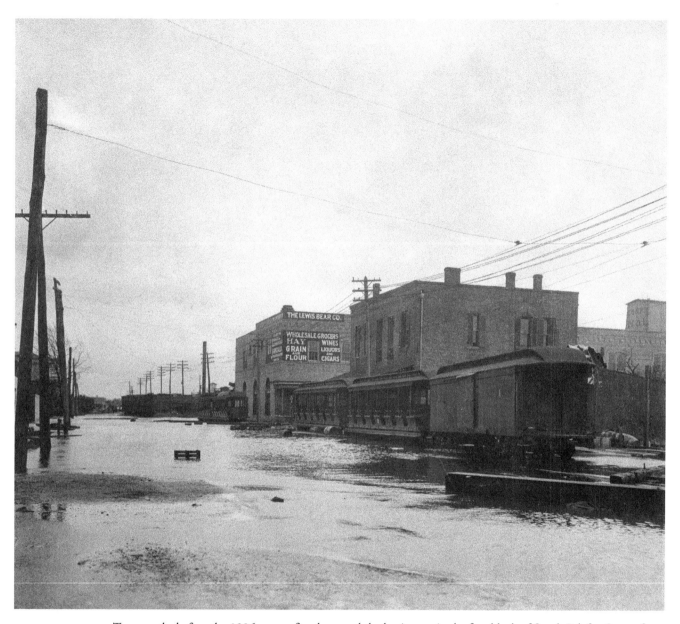

Ten months before the 1906 storm, fire destroyed the businesses in the first block of South Palafox Street, from Garden to Romano streets. Pensacolians endured their last yellow fever epidemic in 1905, just before medical advances eradicated the disease. This view of East Main Street shows the Lewis Bear Company and the Pensacola Electric Company trolleys after the 1906 storm.

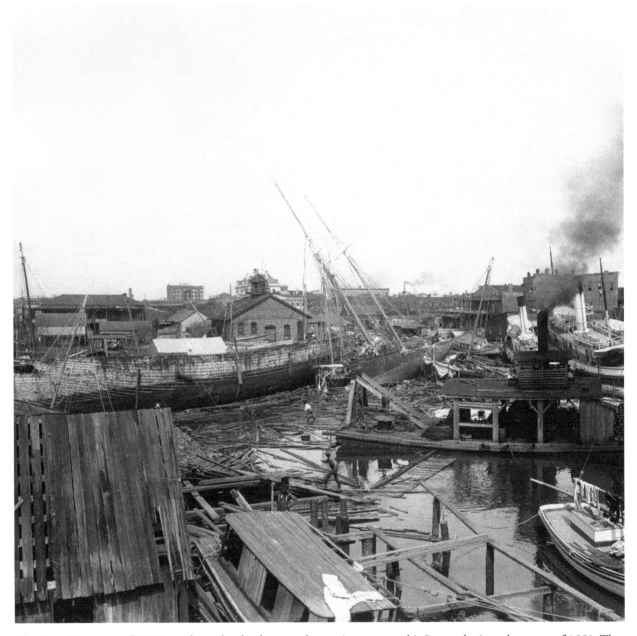

The Great Hurricane of 1906 was deemed to be the most devastating storm to hit Pensacola since the storm of 1559. The hurricane damaged more than 5,000 homes, left more than 3,000 Pensacolians homeless, and killed 134 people.

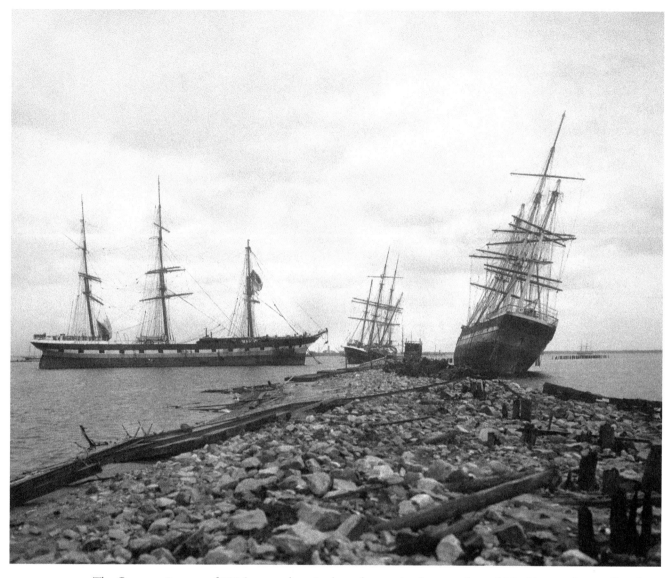

The Category 3 storm of 1906 came ashore in the early morning hours and set a high-tide record at ten feet above normal. The storm serge deposited some boats on ballast rock in the harbor and left others three blocks inland. Winds of 94 miles an hour were recorded before the anemometers at the weather stations were destroyed.

Although the Consolidated Grocery store was at the corner of Chase and Alcaniz streets, the office was located in the Citizens National Bank building at 228 South Palafox. The Pensacola Opera House, at the corner of Jefferson and Government streets, is visible in the background.

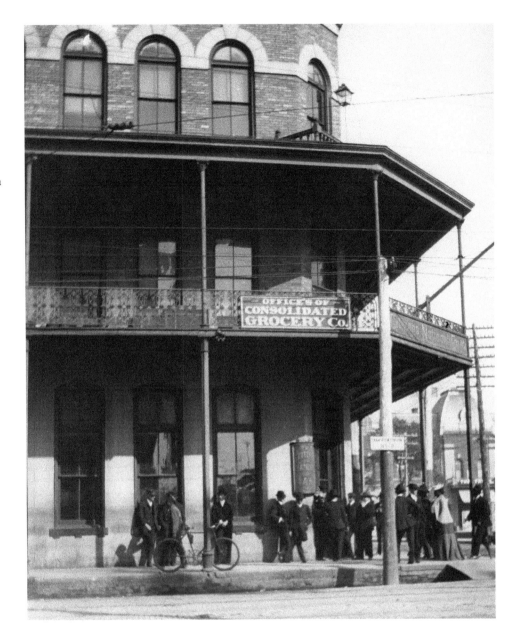

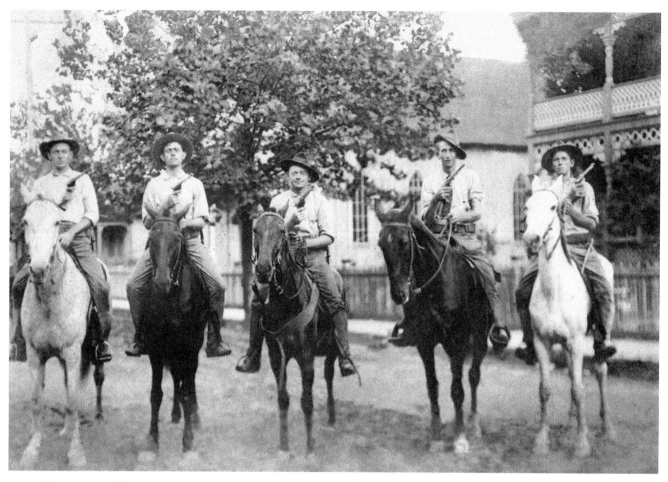

Employees of the Pensacola Electric Company went on strike in April 1908, stopping all trolley service in the city. After the company hired strikebreakers, Governor Napoleon B. Broward ordered the state militia to Pensacola to control unrest and restore order. The mounted patrol of Company L was prepared to maintain peace in the city.

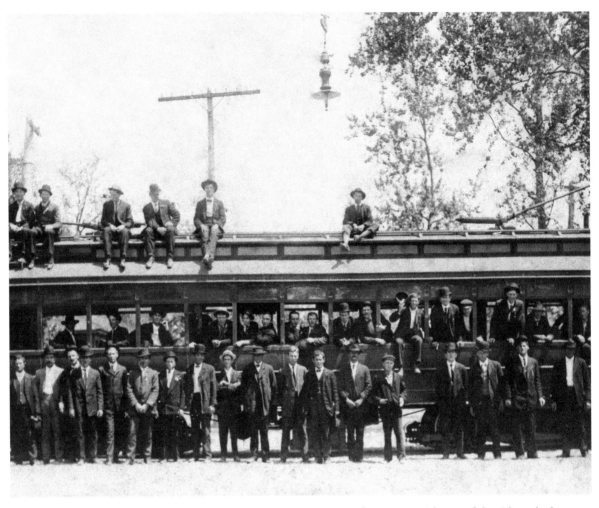

The trolley strike lasted for several weeks. On April 6, 1908, a group of men pose with one of the sidetracked streetcars.

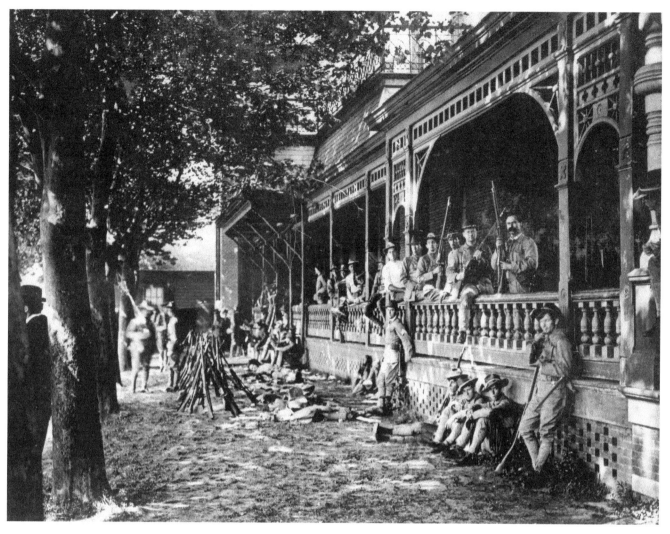

The companies of state militia ordered to Pensacola during the trolley strike set up camps along Palafox Street. These men are guarding the officers quarters established at the Escambia County Courthouse on North Palafox.

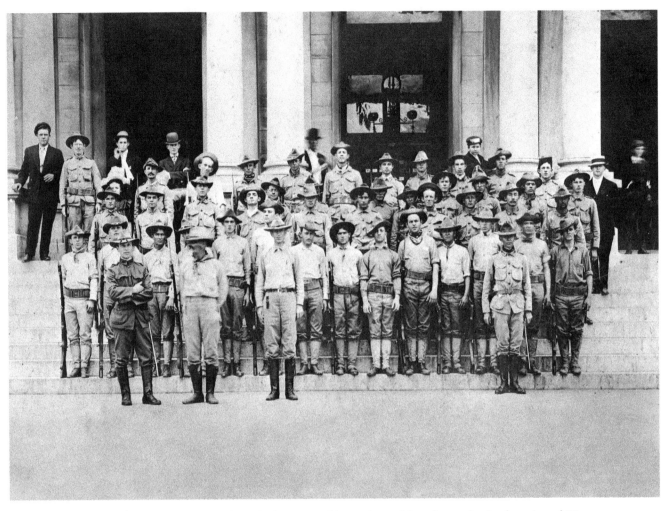

The militia was ordered to report to Pensacola under heavy marching orders, with each man having been issued 20 multiple ball cartridges. Two Gatling guns were also moved into the city. These members of the militia pose on the steps of the Customs House and Post Office on South Palafox.

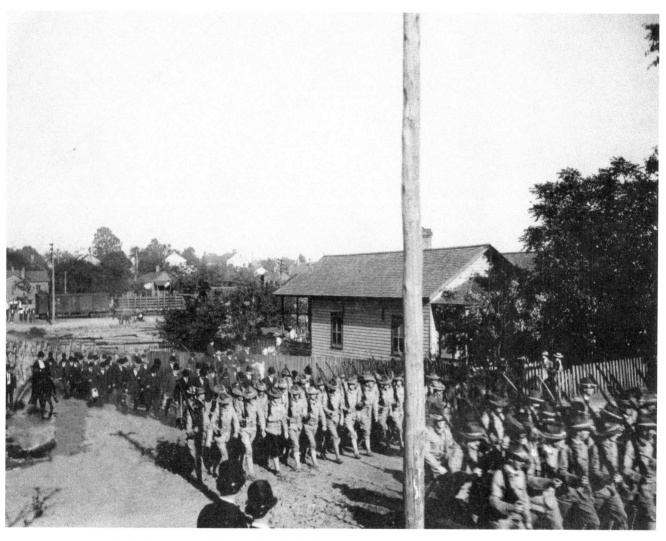

Strikebreakers were hired in New York City and were escorted through the city by the militia after arriving in Pensacola by train. The strikebreakers, with militia protection, reinstated service on April 14, 1908. On April 21, a mob attacked one of the streetcars, killing conductor G. Hoffman.

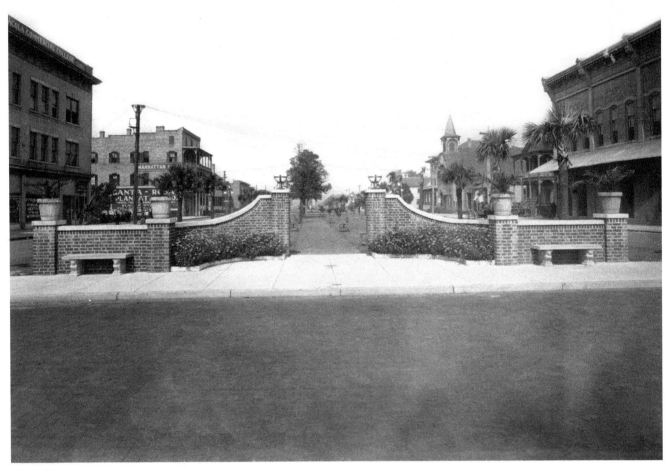

Early in the twentieth century, a handsome brick wall fronted the pedestrian walkway in the median of West Garden Street. The Pensacola Commercial College and the Manhattan Hotel are also visible in this image, at left. The steeple of Immanuel German Lutheran Church appears at right.

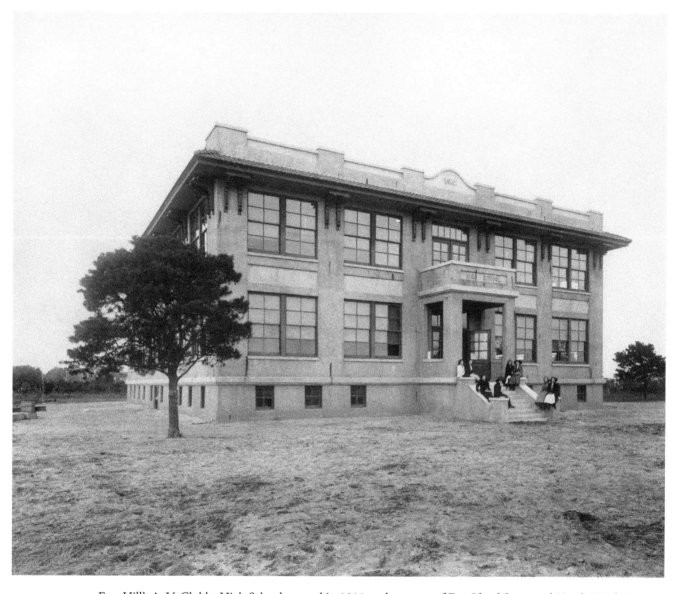

East Hill's A. V. Clubbs High School opened in 1911 at the corner of East Lloyd Street and North Ninth Avenue. By 1950, the school was operating as Clubbs Junior High. Named for local contractor A. V. Clubbs, the school was erected at a cost of $557,812.

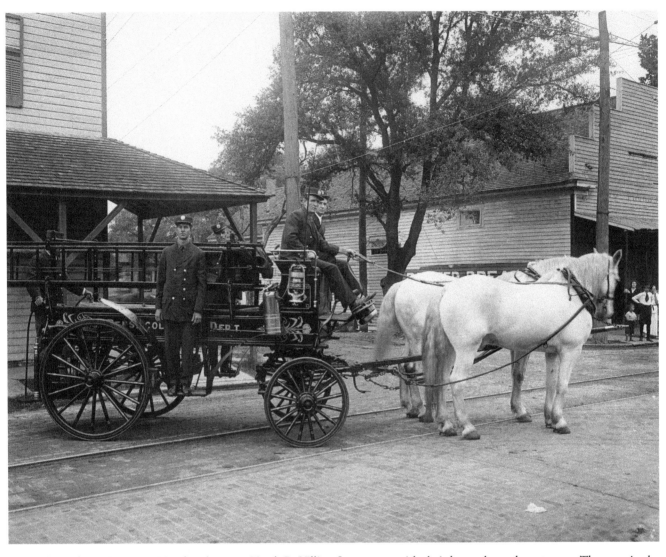

Members of Fire Company Number 4, at 519 North DeVilliers Street, pose with their horse-drawn hose wagon. The store in the background is a grocery owned by James E. Williams, who was also the county treasurer.

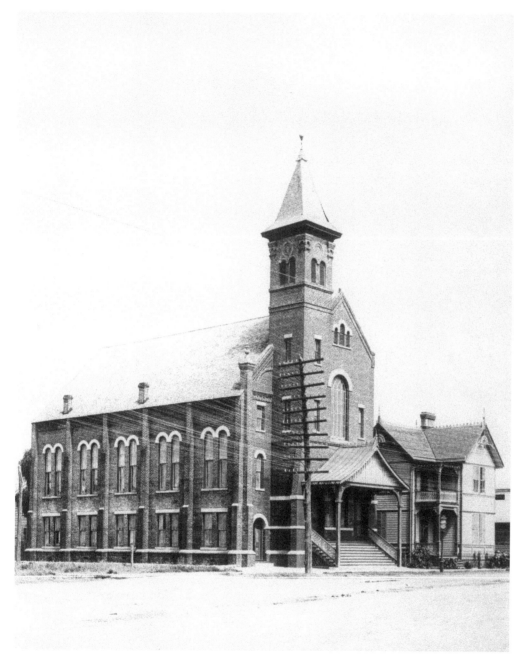

The Methodist Episcopal Church was at the corner of North Palafox and West Garden streets. The church relocated to Wright Street and is now the First United Methodist Church. The North Palafox site became the home of the Hotel San Carlos and now holds the Federal Courthouse.

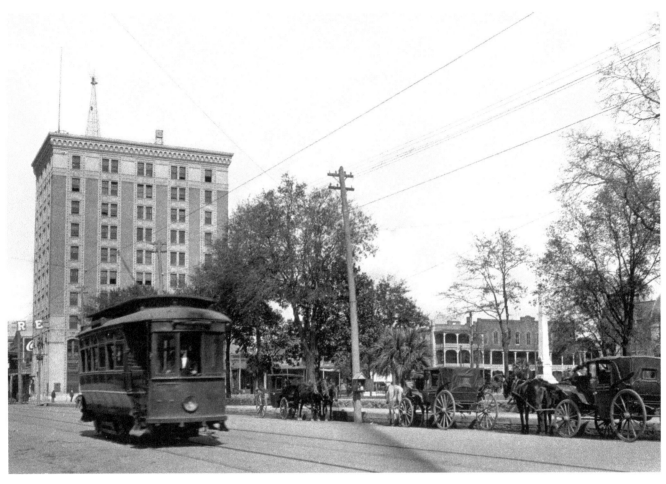

At ten stories, the American National Bank Building was Pensacola's first skyscraper when it opened in 1910. The U.S. Weather Bureau occupied the top floor. Horse-drawn carriages were still plentiful downtown even after electric trolley service began.

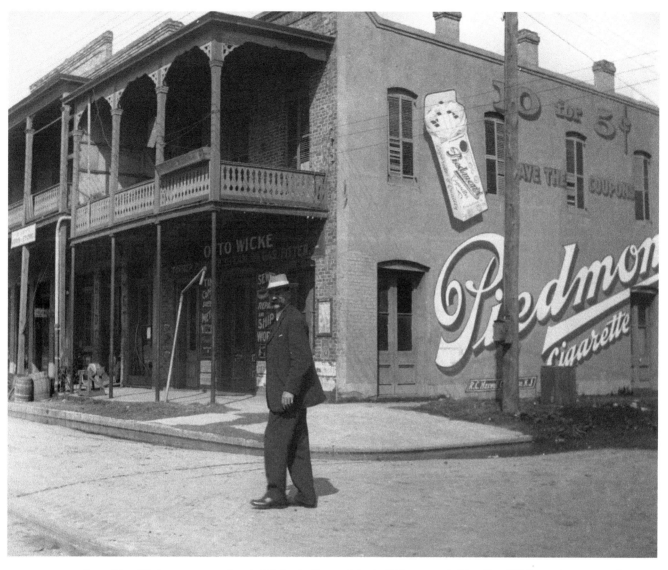

An unidentified man crosses South Palafox in front of the building occupied by Otto Wicke, a tinner specializing in roofing and ship work.

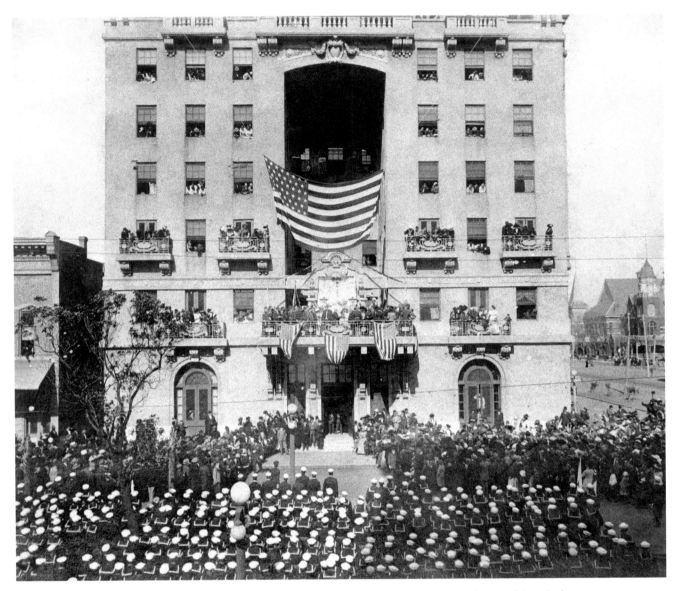

Pensacola threw a big parade for the battle cruiser *Florida* when it came into port in 1911. The Hotel San Carlos dressed for the occasion, and Governor Albert W. Gilchrist delivered gifts for the ship, including a silver service from the state and presents from patriotic groups and civic organizations.

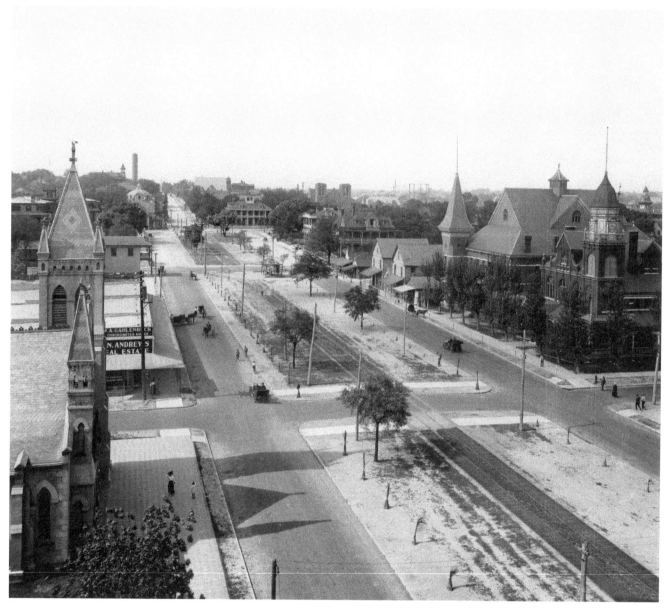

In 1911, Dr. Henry G. Williams, an African American, had an office at the southwest corner of North Palafox and Gregory streets. Mrs. Zarah Mann lived in the building, now known as the Scottish Rite, shown here at center in the background. The water tower still stood on North Hill.

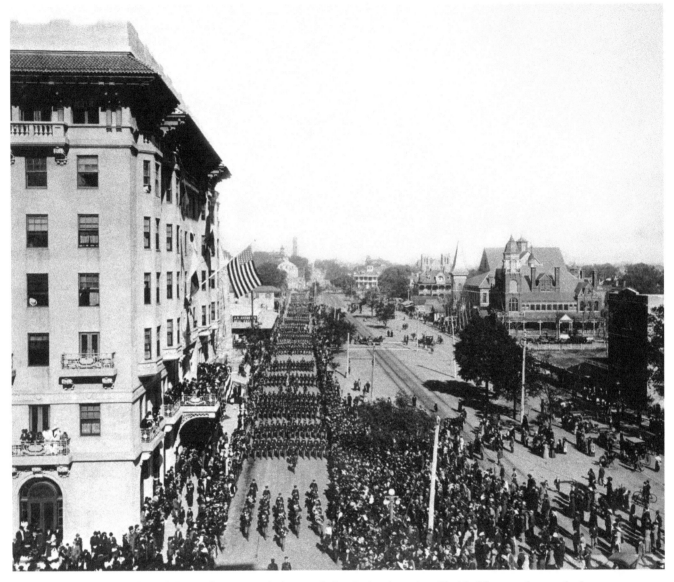

Viewers crowded sidewalks and the median to watch the parade for the battle cruiser *Florida*. The parade stretched for many blocks down North Palafox Street.

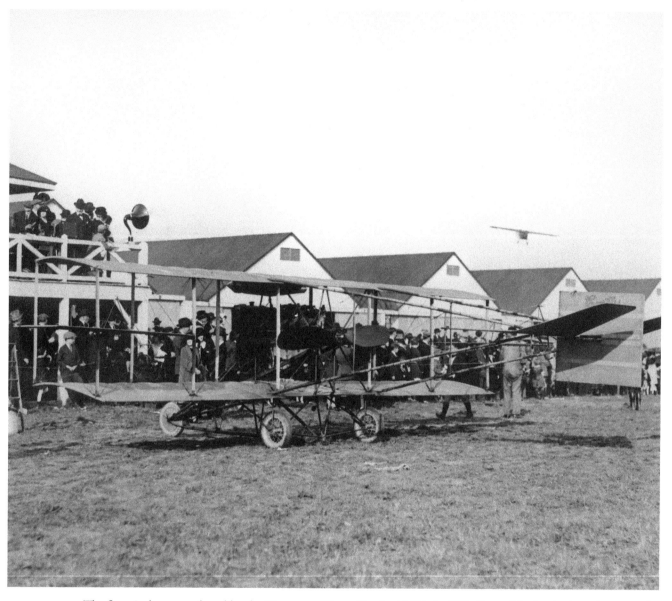

The first airplanes purchased by the Navy were Glenn Curtiss A1 Triads. "Triad" stood for land, air, and water—the planes were amphibian seaplanes.

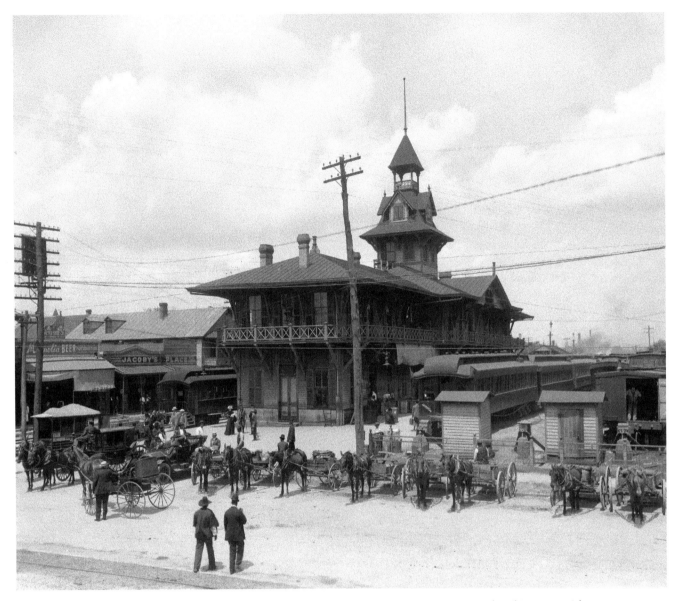

This L&N depot was located at the northeast corner of Wright and Tarragona streets. It was replaced in 1913 with a new depot at the corner of Alcaniz and Wright streets.

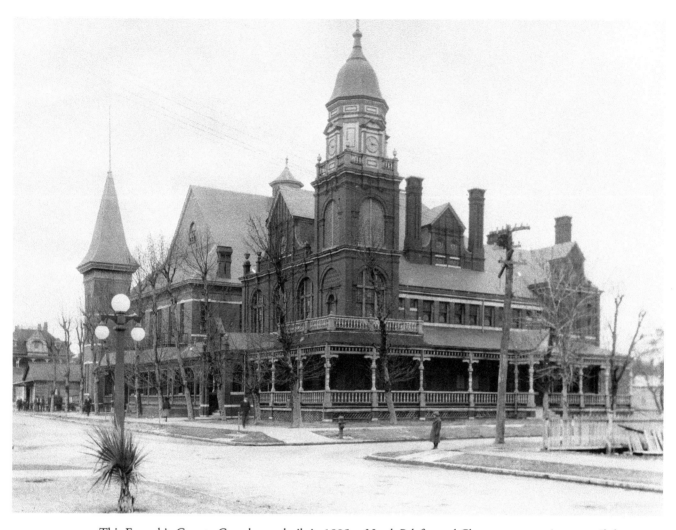

This Escambia County Courthouse, built in 1885 at North Palafox and Chase streets, was in use until the county offices moved to the old Customs House at South Palafox and Government streets in 1939. The old courthouse was demolished, but the clock in the tower, rescued by the Pensacola Historical Society, is now at the corner of South Palafox and Government streets.

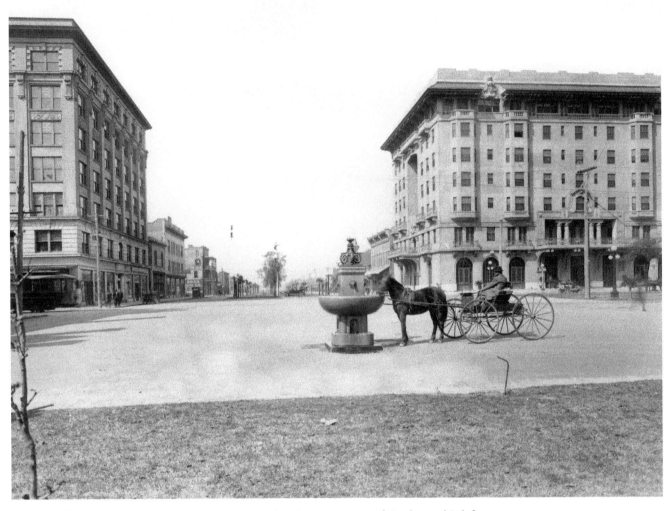

Dr. Louis Blocker donated this fountain, which stood at the intersection of Garden and Palafox streets. The Blount Building and the Hotel San Carlos rise in the background.

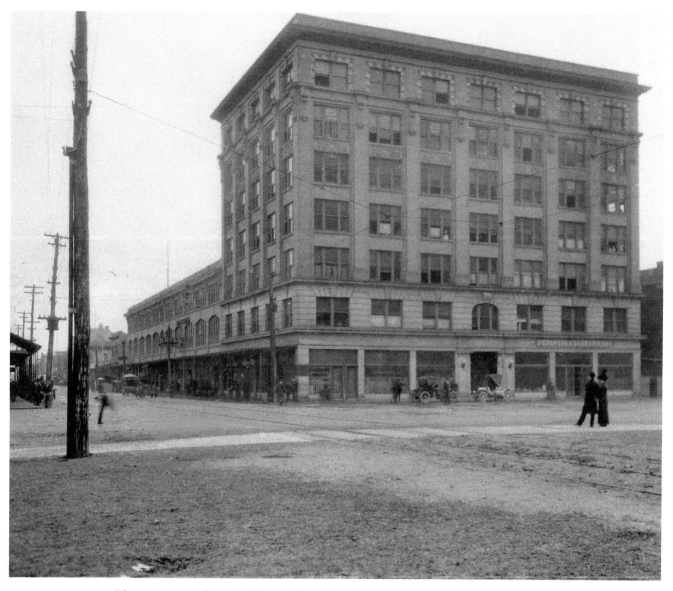

The seven-story Blount Building still stands at the intersection of Palafox and Garden streets. Erected in 1907 by Pensacola attorney William Alexander Blount, the building cost $200,000. This building replaced one that burned on Halloween 1905.

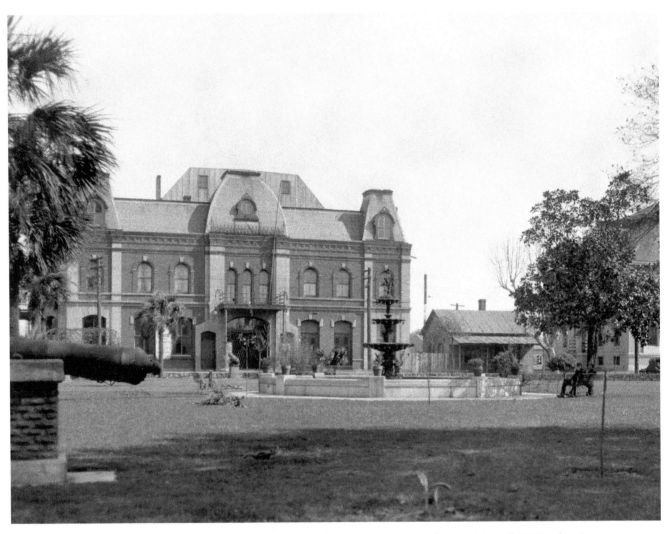

The Pensacola Opera House stood at the corner of Jefferson and Government streets from 1883 until 1917, when it was destroyed by a hurricane. The Opera House hosted some of the most famous artists of the time: Sousa's Band, Sarah Bernhardt, Lillian Russell, Grace George, John Drew, and Billie Burke were a few of the featured performers. The original brick-and-iron balcony rail is now installed in the Saenger Theater.

J. P. Sandusky was president of the Star Laundry Company, located at 37 East Garden Street. In 1912, the delivery wagon still had to negotiate many miles of unpaved streets.

Ten-year-old Richard Bingham (right), son of Frasier F. and Fannie A. Oerting Bingham, travels on public transportation in 1912.

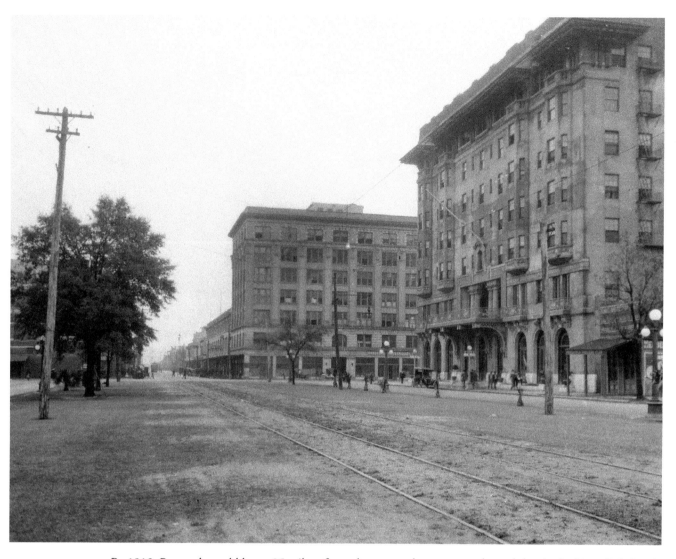

By 1912, Pensacola could boast 25 miles of paved streets and streetcar tracks, and the city had installed electric streetlights. The opening into the interior courtyard of the Hotel San Carlos is visible on the right.

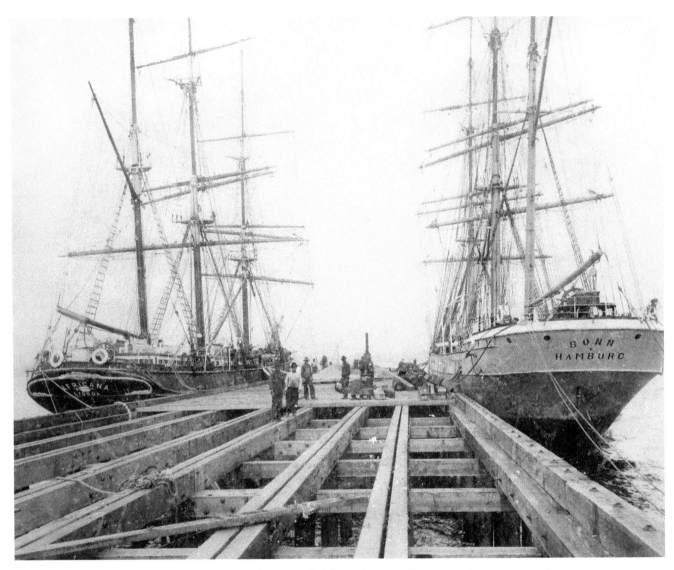

Though still under construction, the new Gulf, Florida, and Alabama Railway pier was put into service on January 1, 1913. The railroad was extended into Pensacola to transport timber harvested in Alabama to the deep-water harbor for shipping.

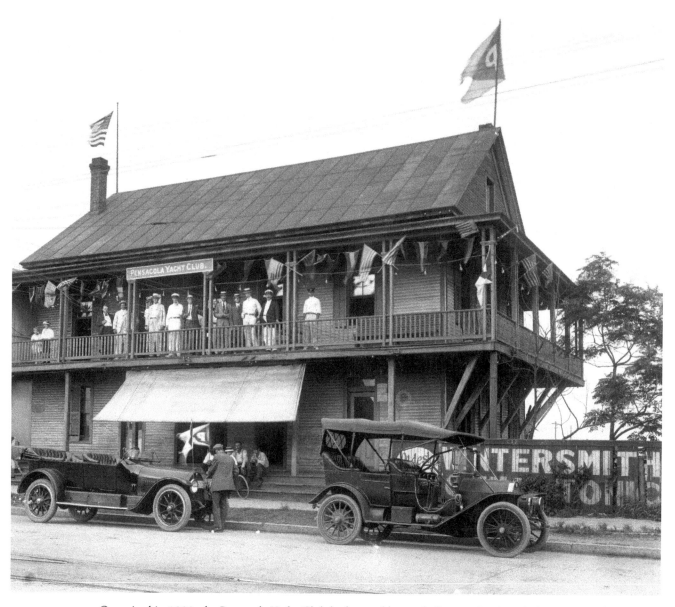

Organized in 1908, the Pensacola Yacht Club had several homes before moving into their permanent location on Cypress Street. In 1913, the club was located on the second floor of the Fisher Building at the corner of Main and Alcaniz streets.

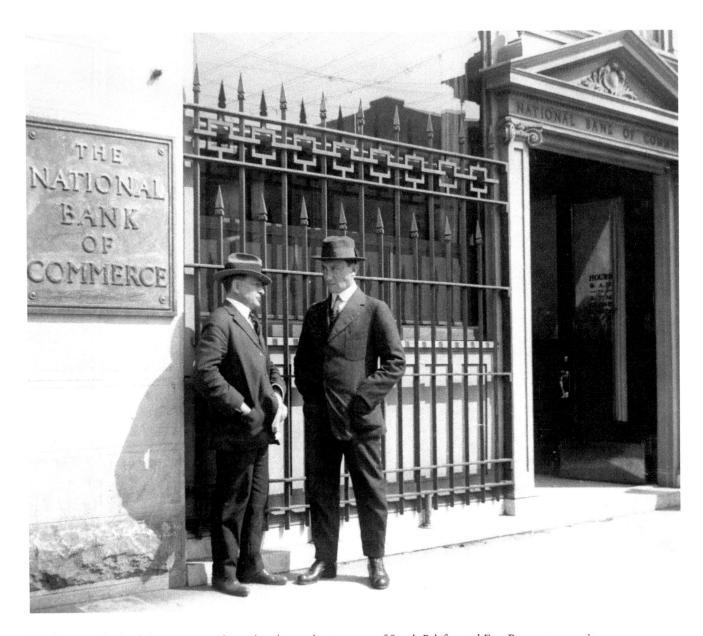

The National Bank of Commerce was located at the northeast corner of South Palafox and East Romana streets in the Thiesen Building.

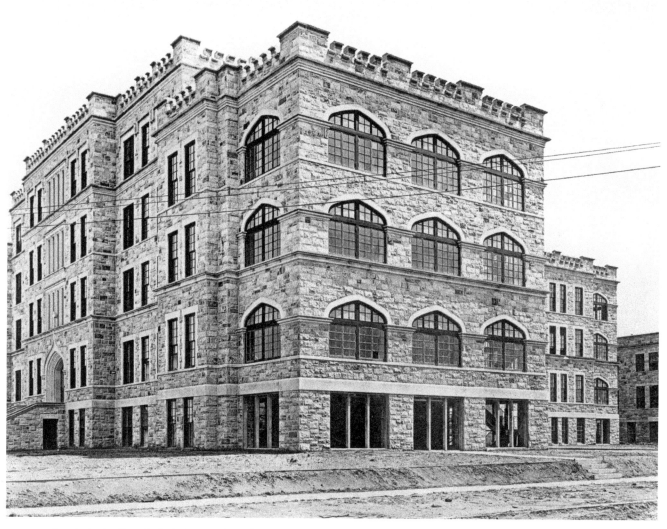

In 1915, the first Catholic hospital in Florida opened as the Pensacola Hospital in this Gothic Revival building. Renamed Sacred Heart Hospital in 1948, the hospital relocated to North Ninth Avenue in 1965. The building housed the Pensacola School of Liberal Arts from 1969 to 1978, and now holds restaurants and business offices.

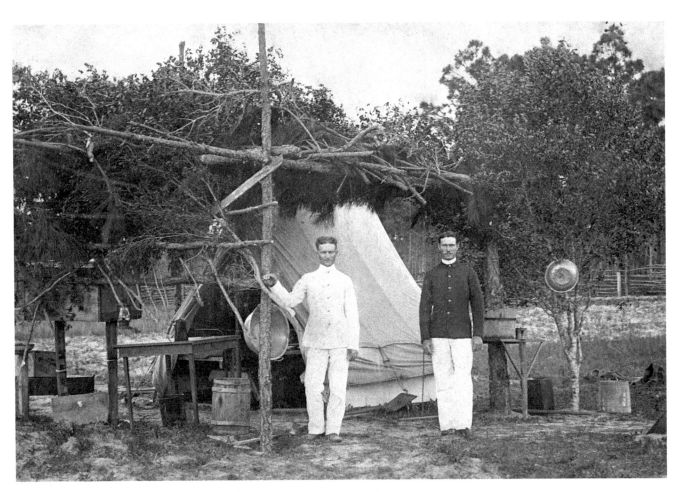

Obid Richards visited with a World War I soldier at his camp in Pensacola.

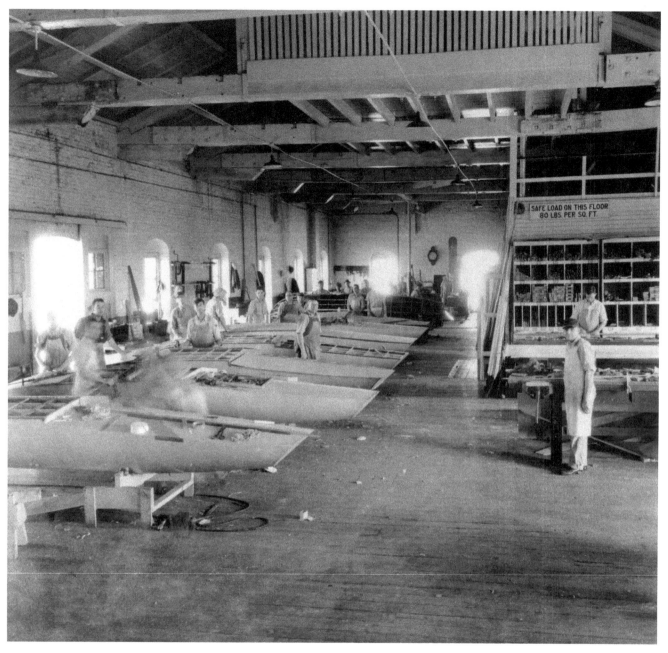

The Pensacola Naval Air Station was the site of the Navy's first naval aviation assembly and repair depot.

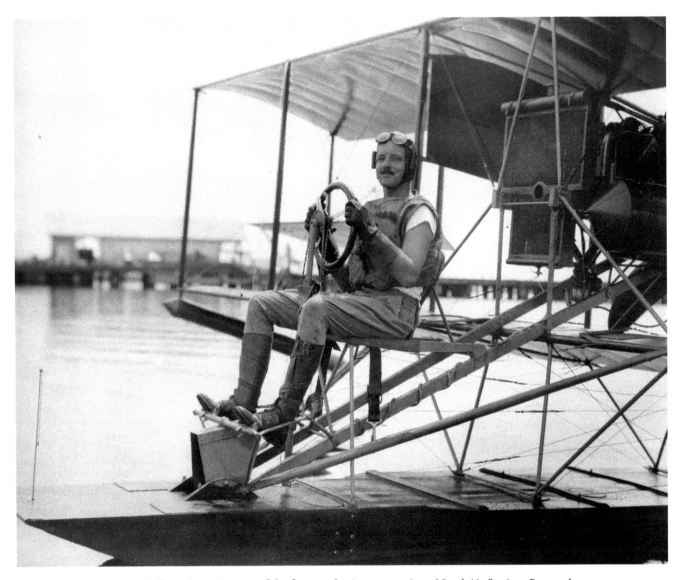

Lieutenant Commander William Corry, Jr., one of the first naval aviators to train at Naval Air Station, Pensacola, was designated Naval Aviator Number 23 in March 1916. Corry died in July 1920 from burns he suffered while attempting to rescue another officer from the burning wreckage of their airplane. Corry Field, opened in 1923 and relocated to its present home in 1928, is named for him.

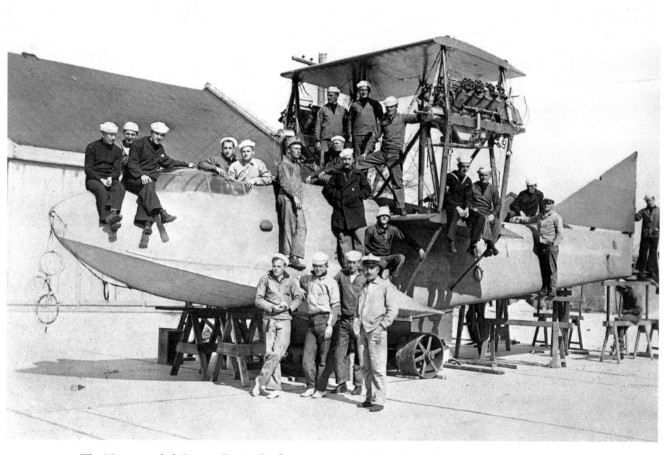

The Navy awarded George Curtiss the first contract to build airplanes for its new aviation branch. The design of the Curtiss HS flying boat placed the engines above the fuselage, away from the water.

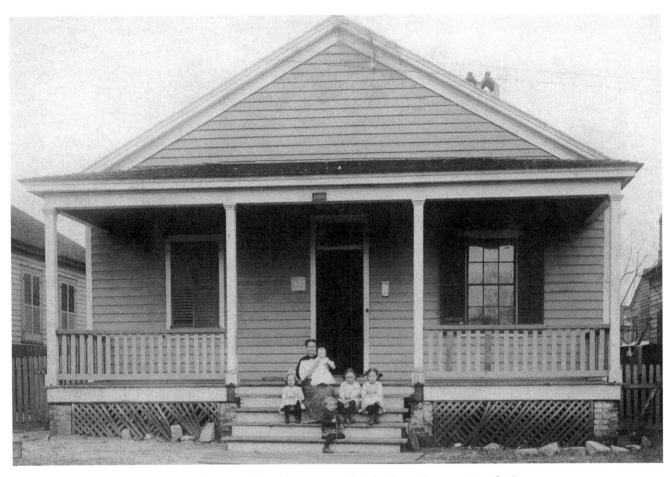

The family of Charles White sits on the steps of their house at 109 Florida Blanca Street waiting for Papa to come home. Pictured left to right are Bessie, Evolyn holding Ruby, Freddie, Louise, and Clara in this 1912 photograph.

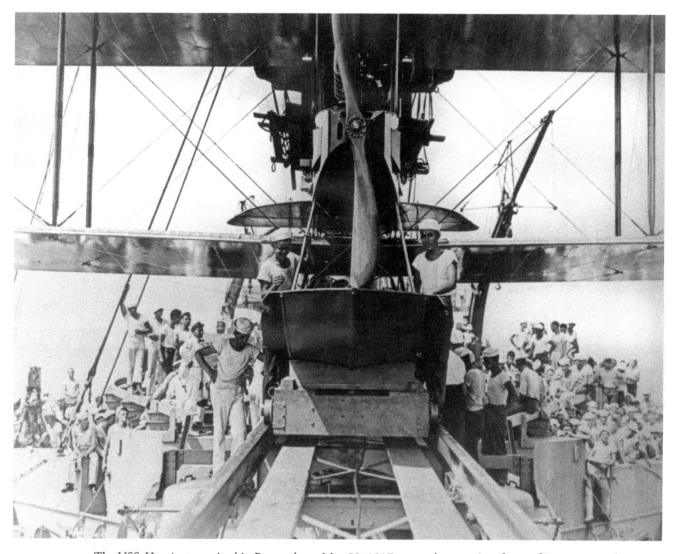

The USS *Huntington* arrived in Pensacola on May 28, 1917, to conduct a series of tests of its new catapult system. The catapult was installed incorrectly, causing the carriage car to be lost over the side of the ship every time it was used. The catapult was later removed.

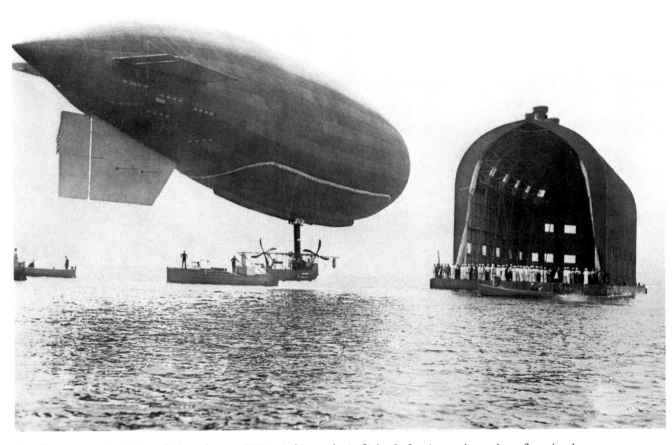

First flown in April 1917, the lighter-than-air DN-1 airship made six flights before it was deemed too flawed to be feasible for use by the Navy. The specially constructed floating hangar, the only floating LTA hangar ever built to house the DN-1, was later used for B-class airships during World War I.

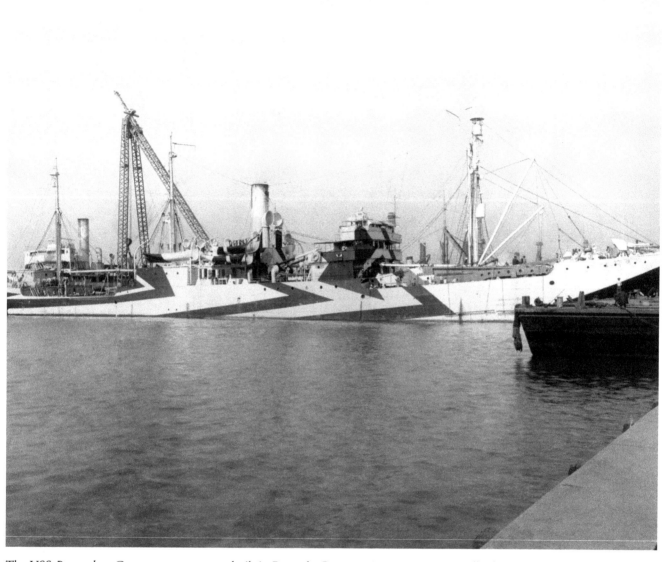

The USS *Pensacola,* a German screw steamer built in Rostock, Germany, in 1901, was originally christened the *Nicaria.* The ship was seized by the U.S. government at Southport, North Carolina, May 8, 1917, was transferred to the U.S. Navy, and was commissioned as the *Pensacola* October 8, 1917. The ship was decommissioned March 14, 1925, and sold.

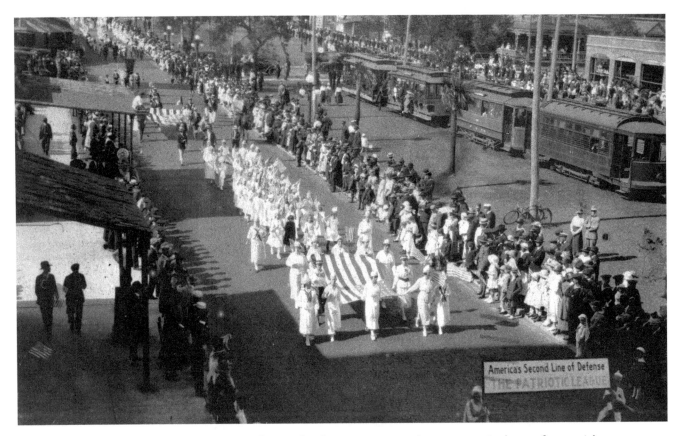

The Patriotic League, known as America's Second Line of Defense, was a women's group organized to perform social services and to support war efforts. The league was very active in Liberty Loan campaigns. This World War I parade was a Liberty Loan Drive to support the war effort.

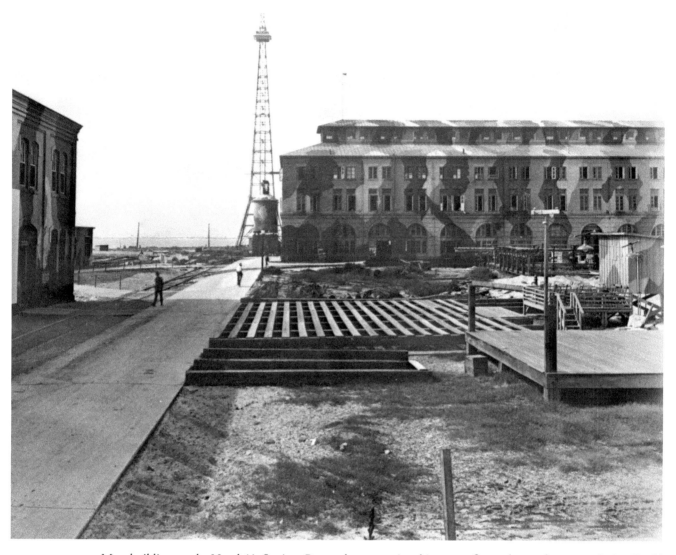

Most buildings at the Naval Air Station, Pensacola, were painted in camouflage colors and patterns during World War I.

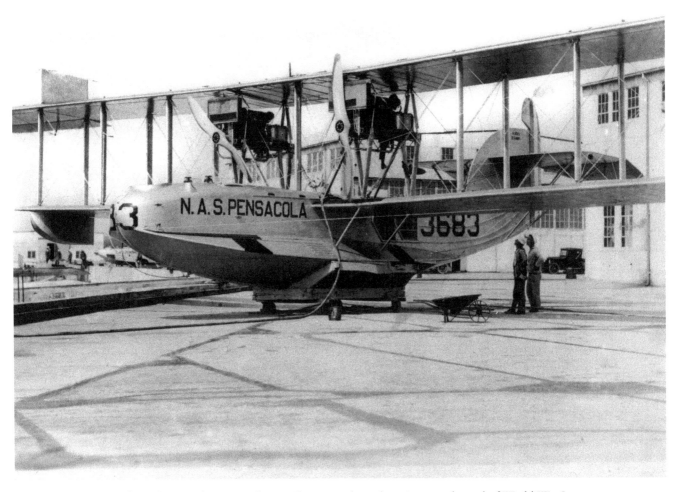

The twin-engine F5L flying boat, with a range of 830 miles, entered naval service near the end of World War I as a patrol plane and was used by the Navy until 1928. This plane could remain airborne for four to six hours.

Between the Wars

(1920–1939)

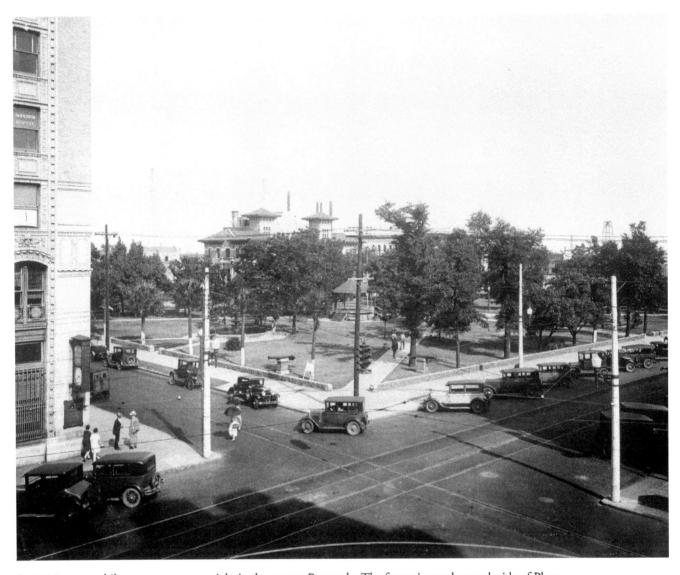

By 1920, automobiles were a common sight in downtown Pensacola. The fountain on the north side of Plaza Ferdinand VII, erected in January 1909, was the first of its kind installed in the city. Replaced in 1963 with a more modern fountain, the original was reinstalled by the city ten years later following public outcry. It is 16 feet tall and features 75 electric lights, a novelty in 1909. The stone wall, made from ballast rock, was erected around the perimeter of the square in 1902.

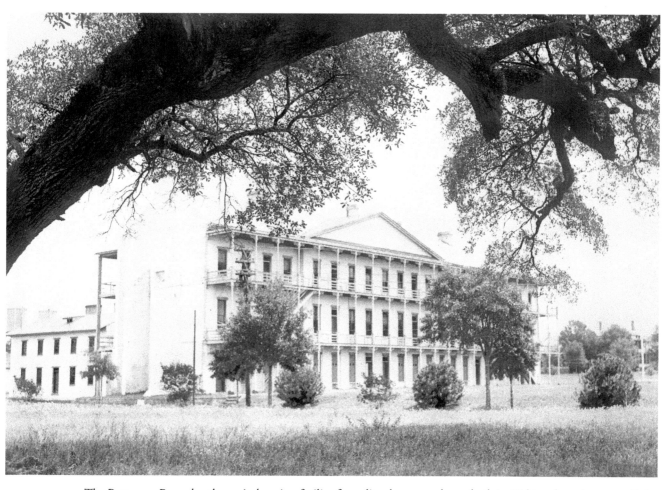

The Barrancas Barracks, the main housing facility for enlisted personnel, was built in 1847 and was in use until the 1930s.

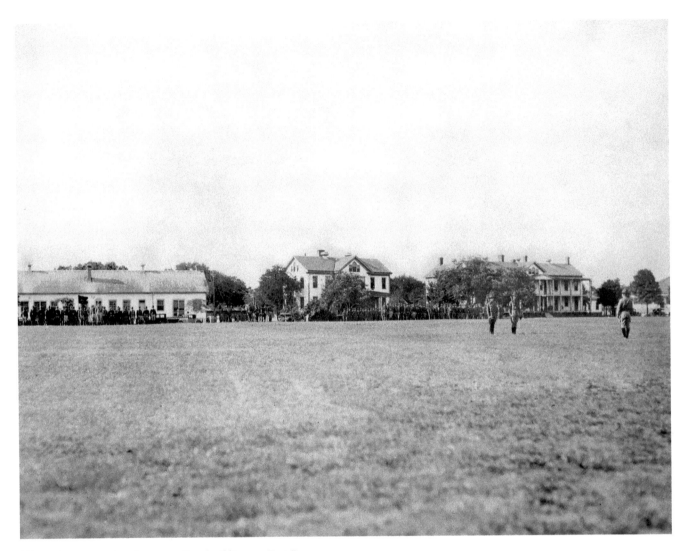

The review ground and surrounding buildings at Fort Barrancas.

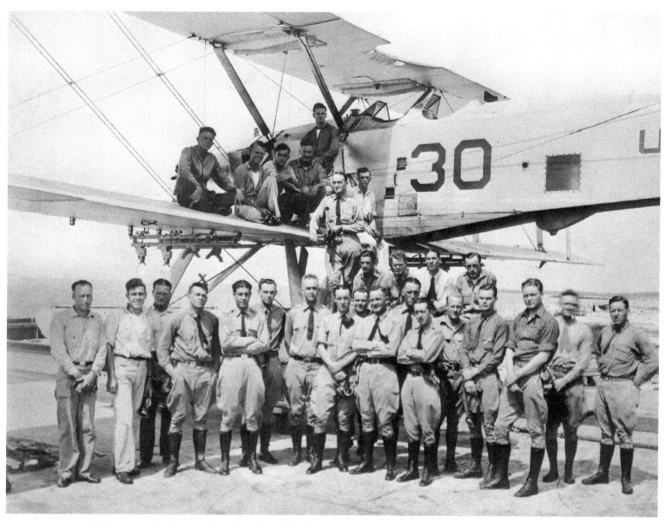

This group of pilots stationed at Naval Air Station, Pensacola, included Luther W. Coleman, Sr., seated third from the left on the wing.

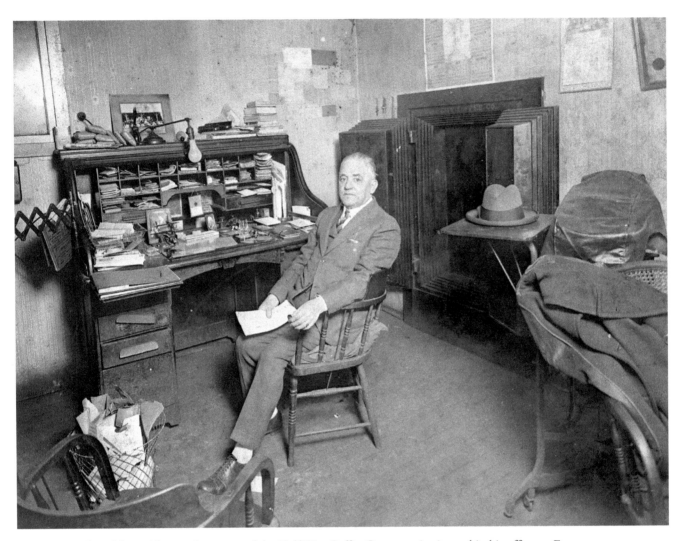

Vincent Joseph Vidal, president and treasurer of the Gulf City Coffee Company, is pictured in his office on East Intendencia Street. The company roasted, blended, and shipped fine coffees for more than 60 years. Mr. Vidal was also Vice-Consul of Guatemala and Uruguay.

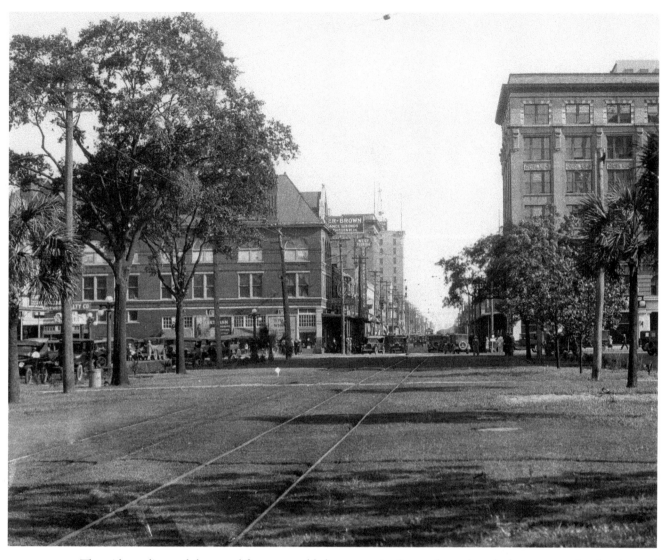

The wide median and deep road frontage enabled a progressive Pensacola to plant shade trees to cool pedestrians and beautify the city.

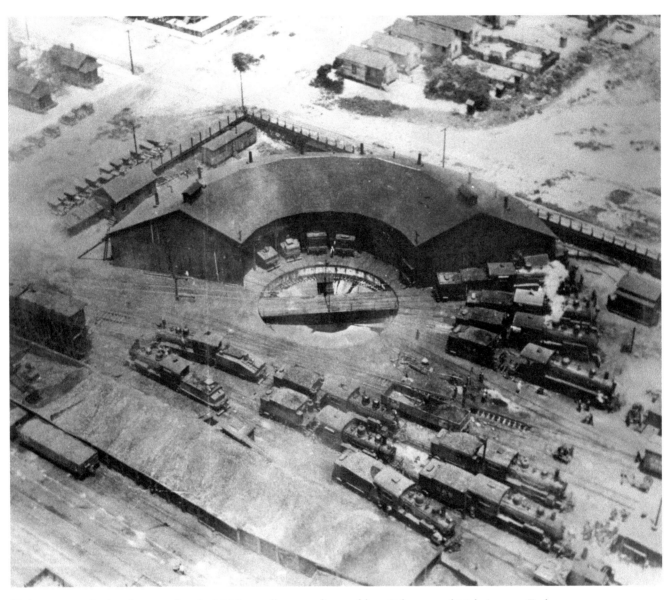

Trains were serviced and rerouted at the L&N roundhouse and turntable at Belmont and 10th Avenue. Early engines were designed only to travel forward. The turntable was used to reverse the engine for the trip out of town.

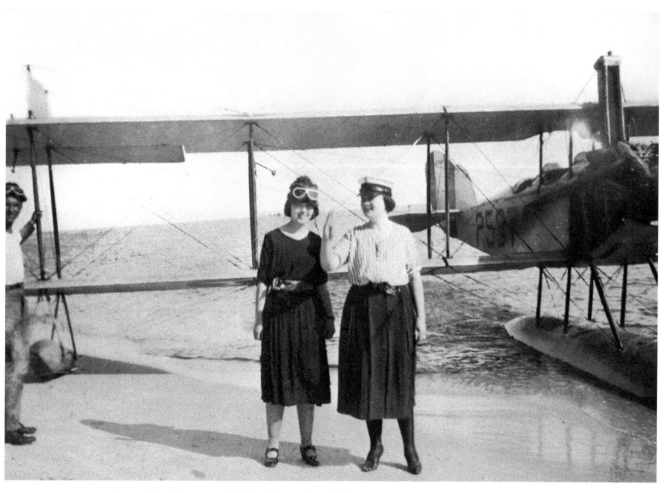

Pensacola is known as the "Mother-in-law of the Navy" because many navy men find wives while stationed at Pensacola. Vergie Cooper and Bessie Cooper became the wives of Navy pilots James Elliott Flynn and William Douglas Faxon.

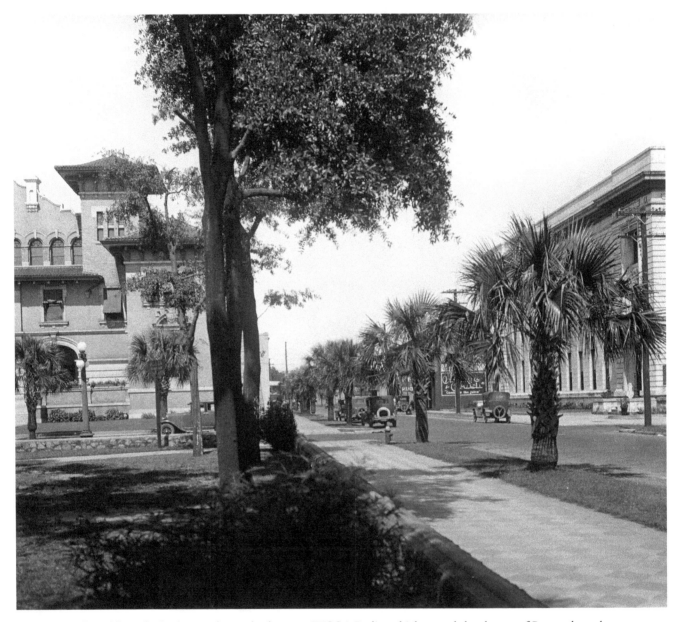

The City Hall, visible in the background, was also home to WCOA Radio, which touted the charms of Pensacola as the Wonderful City of Advantages. The county building to the right held the jail and the sheriff's office, along with other county offices. The old City Hall now houses the T. T. Wentworth, Jr., Museum, and the renovated county building is today home to the Pensacola Cultural Center.

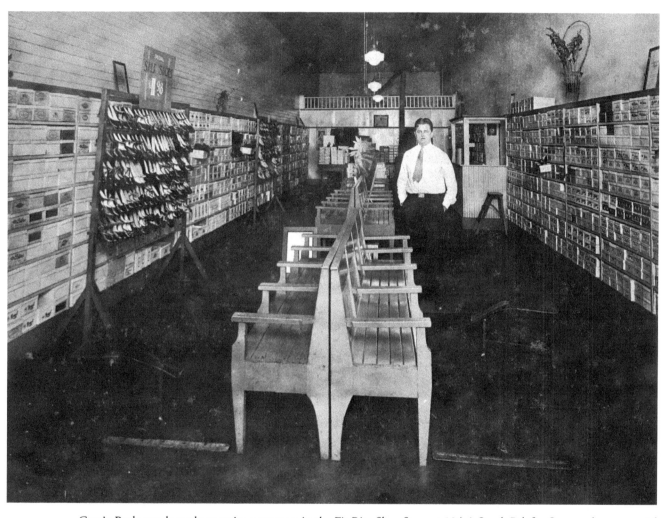

Garcia Beck stands ready to assist customers in the Fit Rite Shoe Store at 124-A South Palafox Street, where a special sale advertises ladies shoes at $1.98. The store was owned by Mr. B. Kaiman.

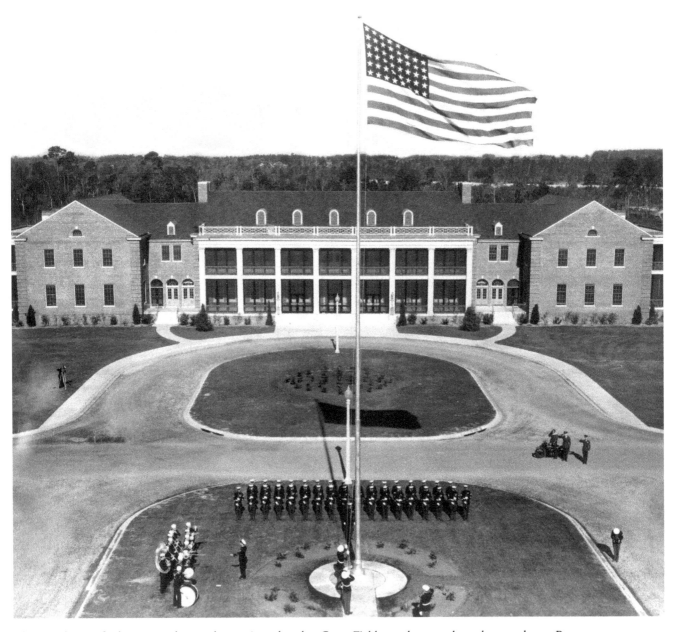

The new designs for hangars and control tower introduced at Corry Field were later used at other area bases. Rear Admiral Ernest King officially dedicated the new buildings December 8, 1934.

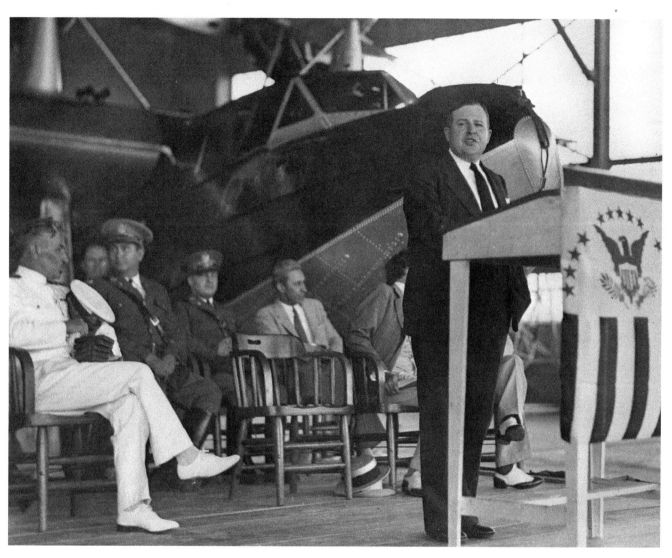

Governor David Sholtz was one of the speakers at the Corry Field dedication ceremony.

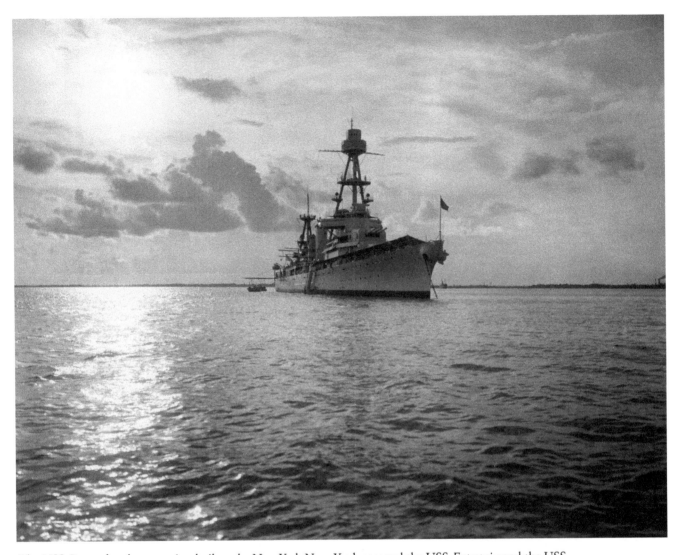

The USS *Pensacola,* a heavy cruiser built at the New York Navy Yard, escorted the USS *Enterprise* and the USS *Yorktown* at the Battle of Midway. The *Pensacola* was torpedoed at the battle of Tassafaronga in 1942 with a loss of more than 120 crewmen. She returned to service in 1943 and participated in battles at Wake Island, Marcus Island, Formosa, and the Battle of Leyte Gulf. The *Pensacola* was decommissioned in 1946.

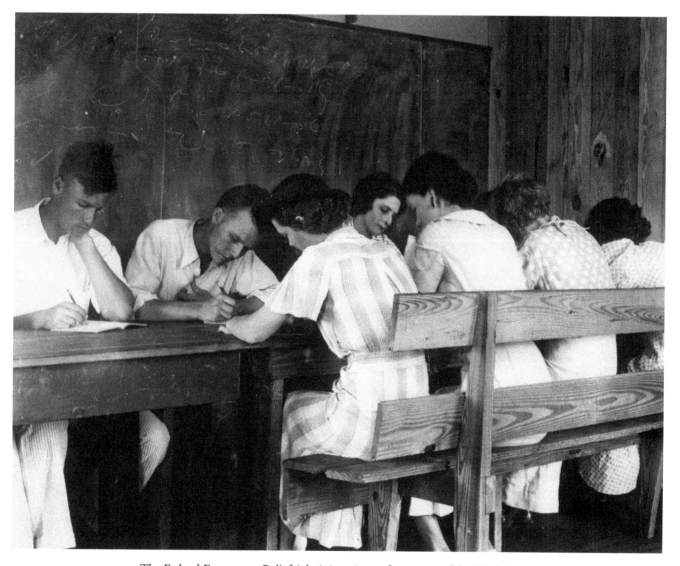

The Federal Emergency Relief Administration, a forerunner of the Work Projects Administration, helped communities during the Great Depression. These students are enrolled in an adult education class taught by the FERA.

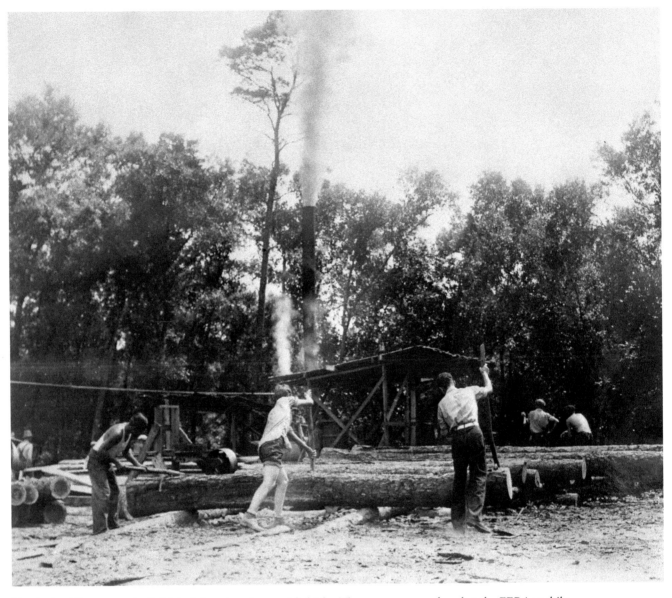

The Federal Emergency Relief Administration also provided jobs. These men are employed at the FERA mobile sawmill transient camp number 2.

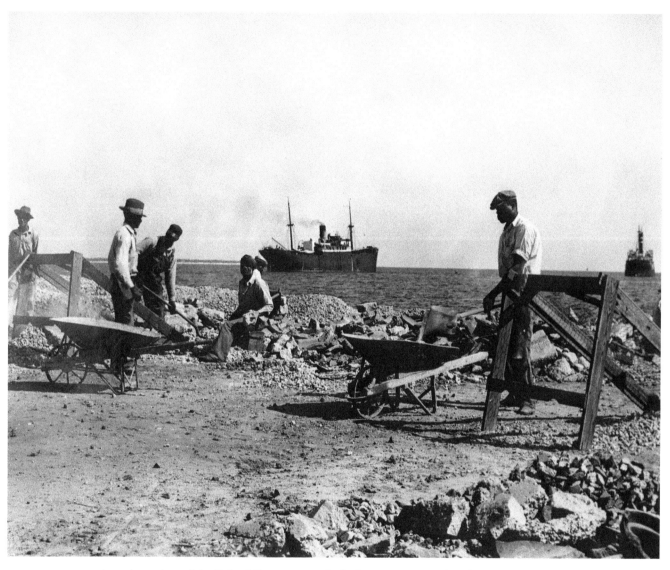

A works project of the Federal Emergency Relief Administration employed men to improve the Pensacola docks.

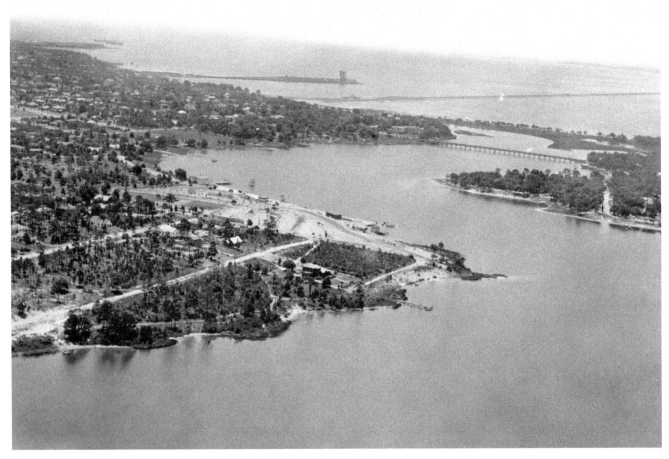

Bayview Park, built on 28 acres of land along Bayou Texar near the turn of the century, offered residents of the expanding city a place to relax and enjoy the water. Today, the park boasts a recreation center, senior center, tennis courts, soccer field, picnic tables, playground, and a dog park. The pier, destroyed by Hurricane Ivan, has been rebuilt.

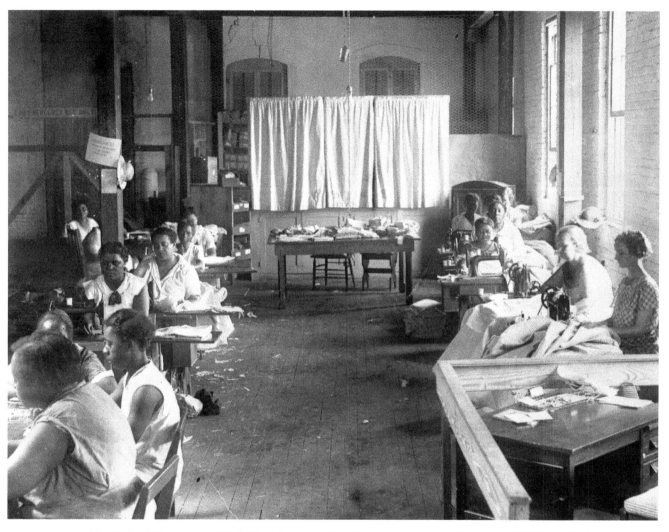

The Federal Emergency Relief Administration also offered opportunities for women. FERA supplied these women with jobs in a local mattress factory.

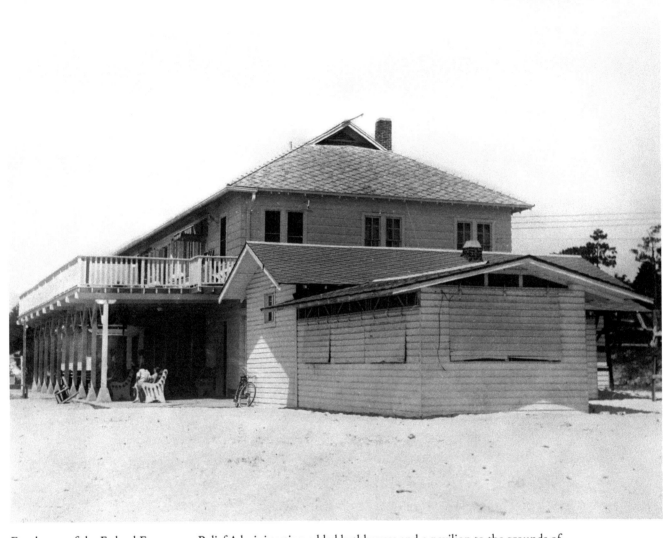

Employees of the Federal Emergency Relief Administration added bathhouses and a pavilion to the grounds of Bayview Park.

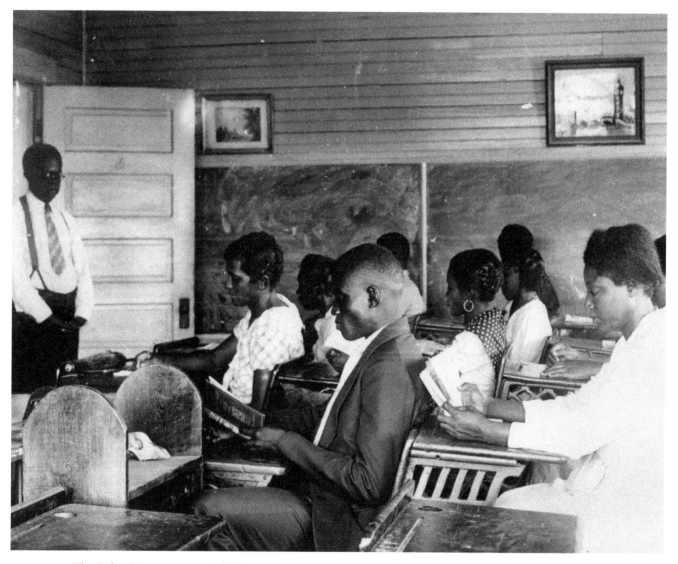

The Federal Emergency Relief Administration offered instruction to adults at Booker T. Washington High School. For some, this was their first opportunity to learn to read and write.

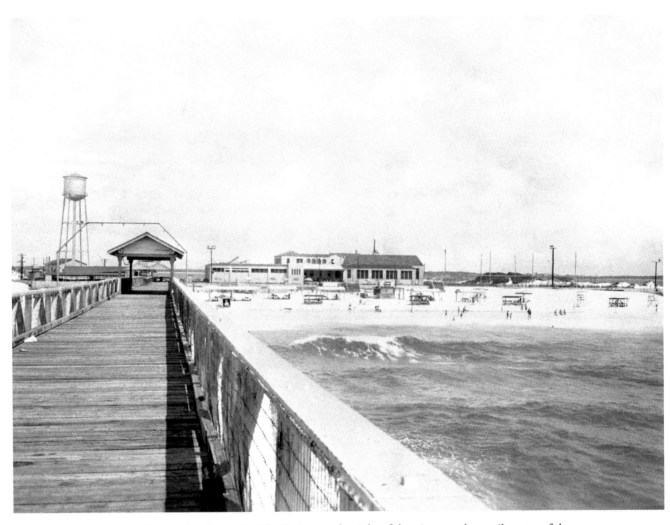

Pensacola Beach was sparsely populated in 1939. The Casino, to the right of the pier, was the retail center of the island. Outdoor concession stands are visible to the left of the pier.

A Changing City

(1940–1960)

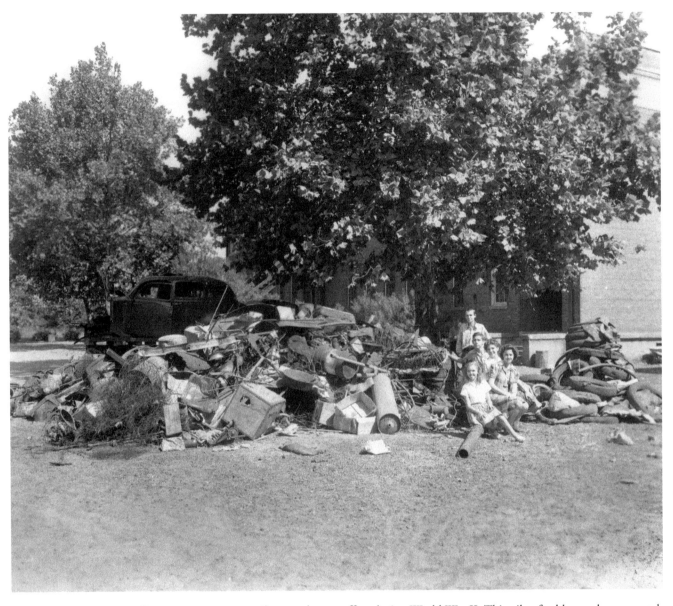

Patriotic Pensacolians were eager to contribute to the war effort during World War II. This pile of rubber and scrap metal, collected in a local drive, was to be recycled into war materiel.

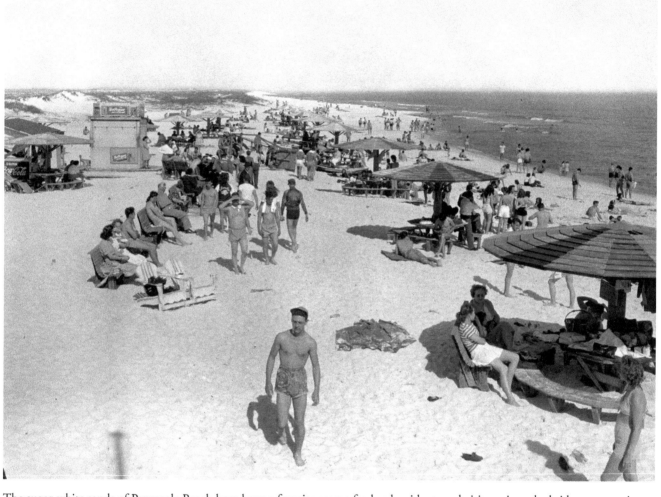

The sugar-white sands of Pensacola Beach have been a favorite escape for local residents and visitors since the bridges connecting Pensacola to Gulf Breeze and Santa Rosa Island were opened in 1931.

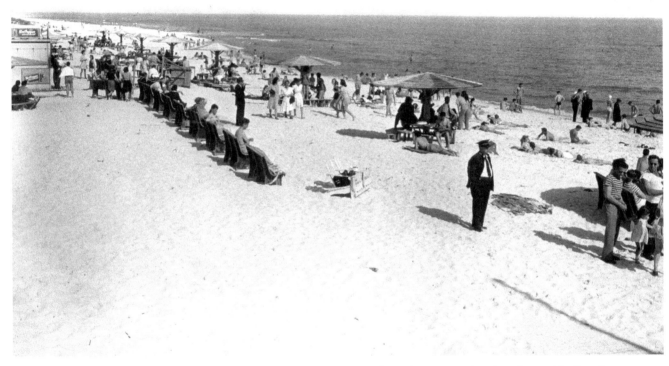

Casino Beach, with its easy access to refreshments and bathhouses, has always been a popular place for seaside diversions.

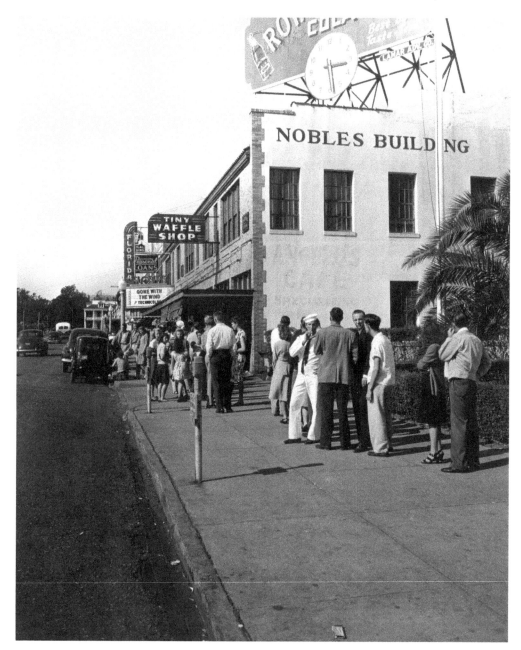

It was not unusual for lines of moviegoers waiting for tickets to the latest show at the Florida Theater to stretch beyond the Federal Building and wrap around the corner. This run of *Gone With the Wind* was no exception.

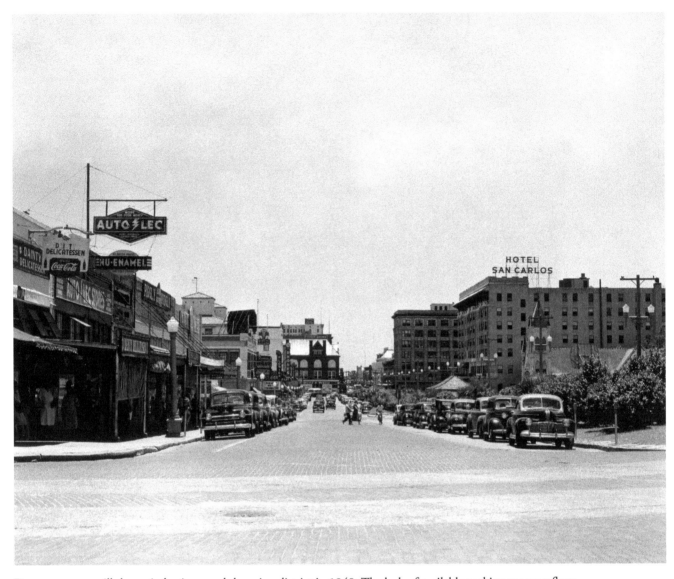

Downtown was still the main business and shopping district in 1948. The lack of available parking spaces reflects postwar development, which led many residents to move farther from the downtown area and drive into town.

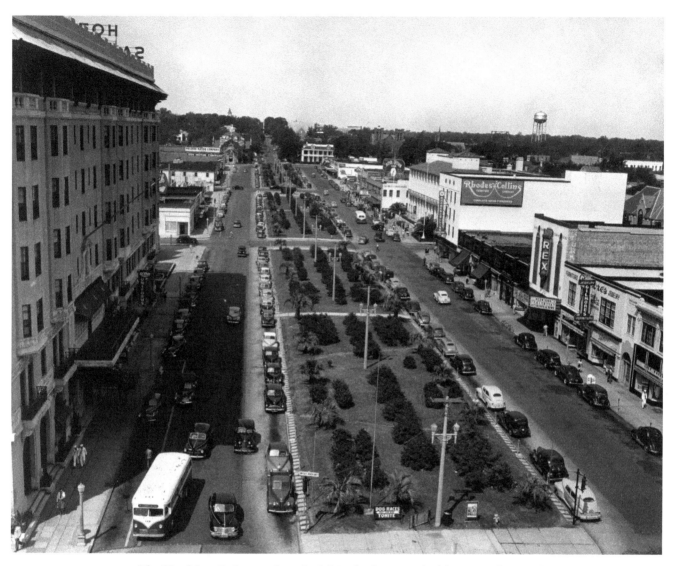

The Hotel San Carlos stands to the left in the foreground of this image from 1947, with the Rex Theater, Rhodes-Collins Furniture Store, the Federal Building, and the Nobles Building prominent on the right. The Scottish Rite Building is visible at the corner of North Palafox and Wright streets. A new, modern water tower is visible on the right in the background, replacing the old brick structure, which has been demolished. Alan Ladd and Gail Russell are starring in *Calcutta* at the Rex while a sign in the median announces "Dog Races Tonite" with a post time of 8:30.

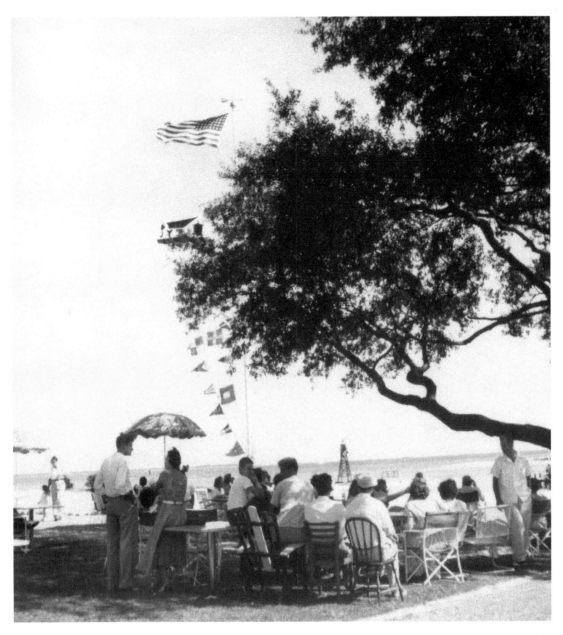

People gather to watch the 1948 Lipton Cup Race in Pensacola.

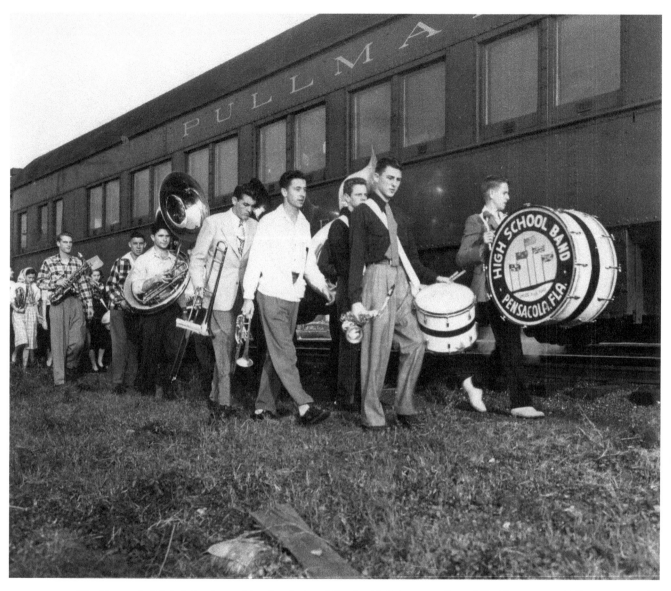

The Pensacola High School marching band played for the 1949 inauguration of Florida governor Fuller Warren. The band was led by director H. Vernon Hooker, captain Charles Hardin, and drum majorette Mary Frances Comstock.

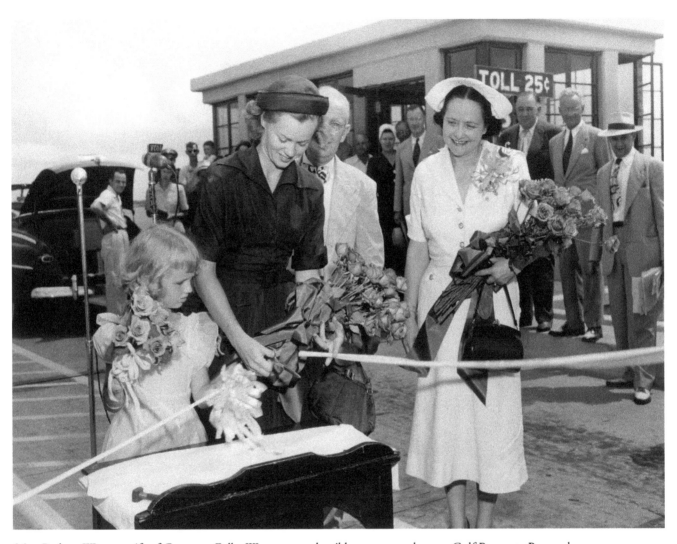

Mrs. Barbara Warren, wife of Governor Fuller Warren, cuts the ribbon to open the new Gulf Breeze to Pensacola Beach bridge. Mrs. Mildred Pepper, wife of U.S. senator Claude Pepper, is to her right.

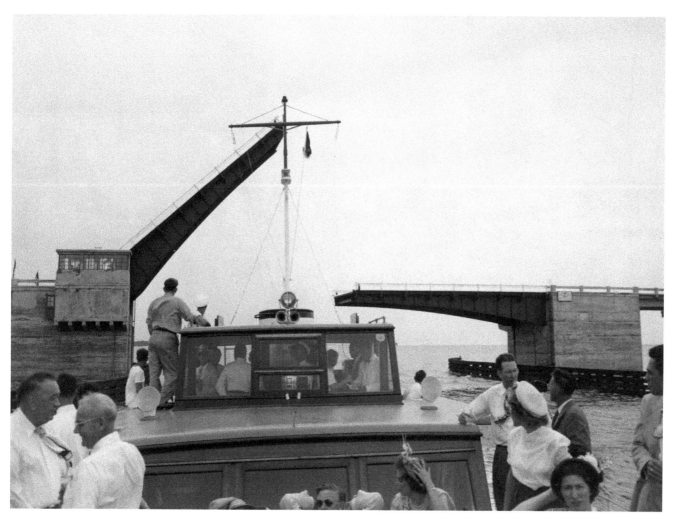

A boat passes under the open drawbridge of the new Pensacola Beach bridge.

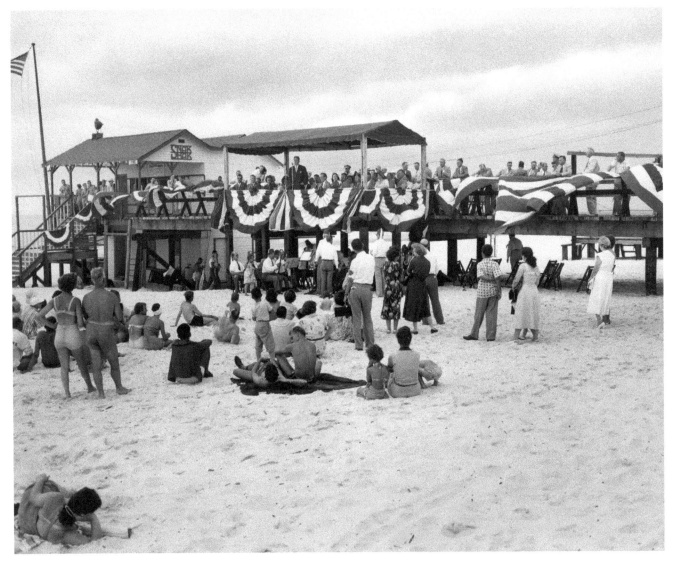

People gather on the beach July 16, 1949, for ceremonies to dedicate the new bridge from Gulf Breeze to Pensacola Beach.

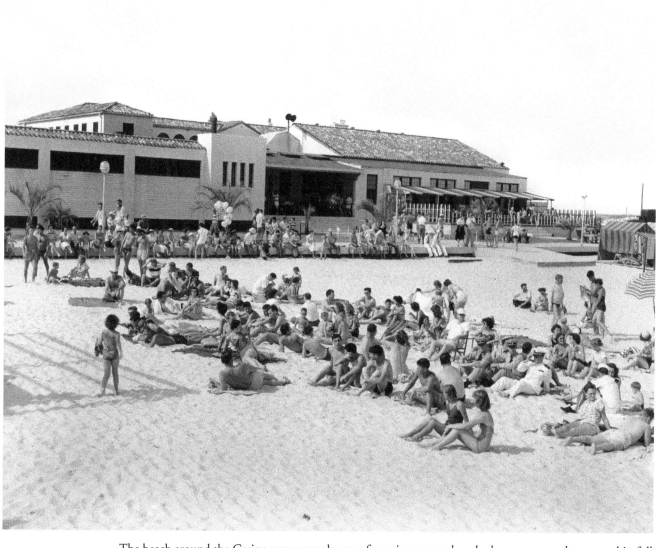

The beach around the Casino was a popular area for swimmers and sunbathers, even naval personnel in full uniform.

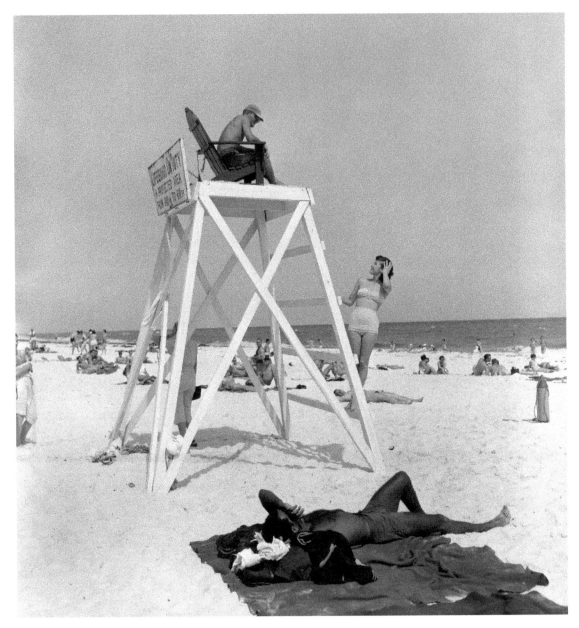

The lifeguard takes his eyes off the water long enough to speak with Rosalie Ivimey.

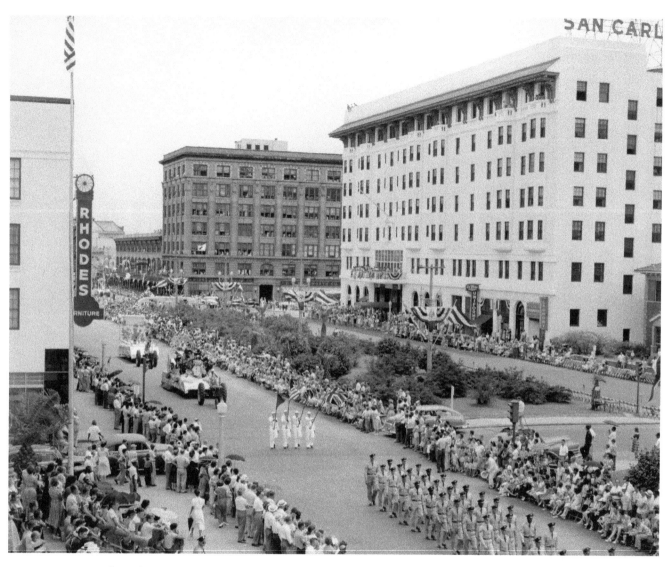

A yearly tradition since 1951, the Fiesta of Five Flags celebrates the 1559 landing of Don Tristan de Luna and the first settlement of Pensacola. Festivities include parades, treasure hunts, and dances.

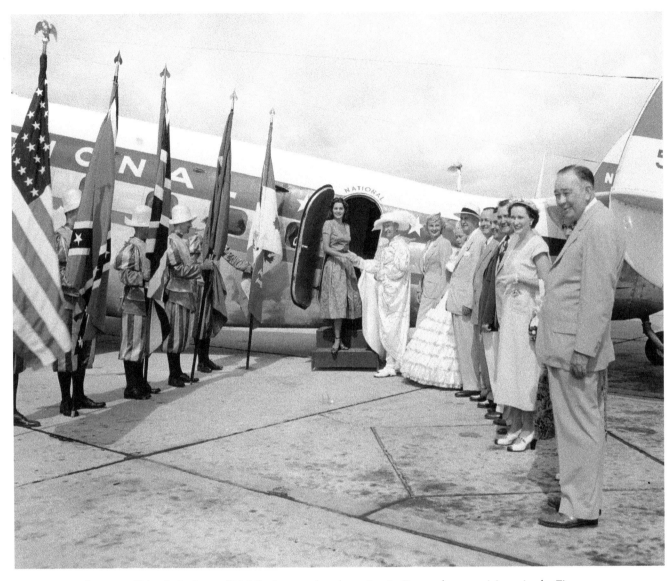

Miss America for 1951, Yolande Betbeze of Mobile, is greeted as she arrives in Pensacola to participate in the Fiesta activities.

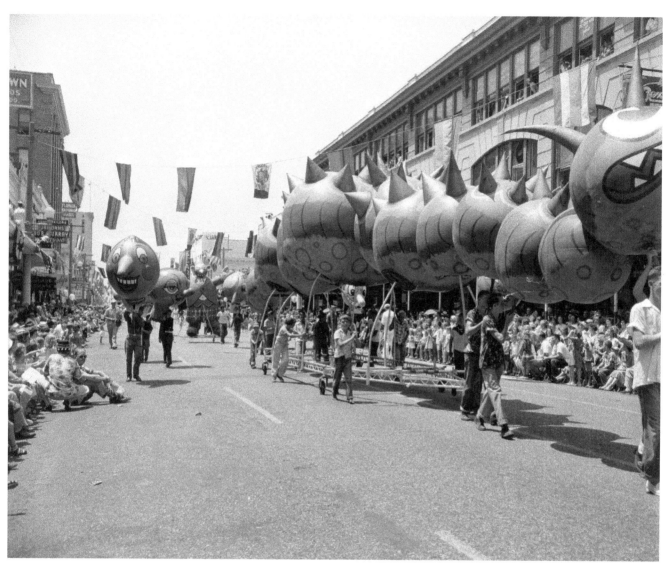

Parades celebrating the Fiesta of Five Flags are popular with children and adults.

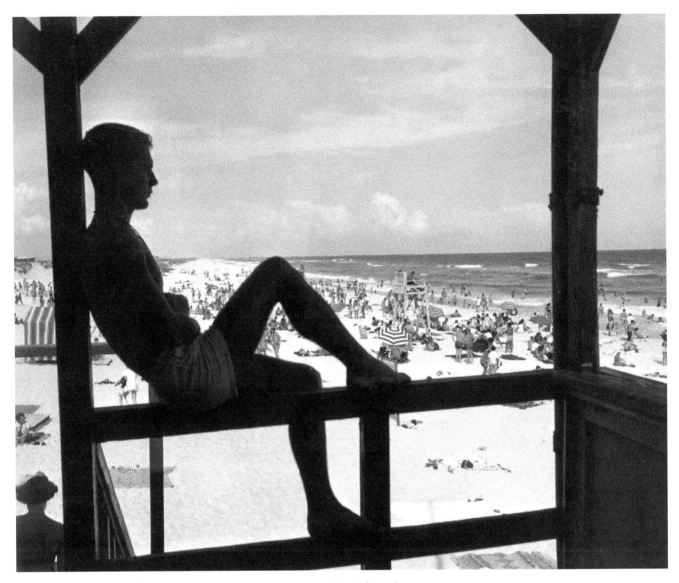

The railing around the Casino patio was a cool spot to relax and hide from the sun.

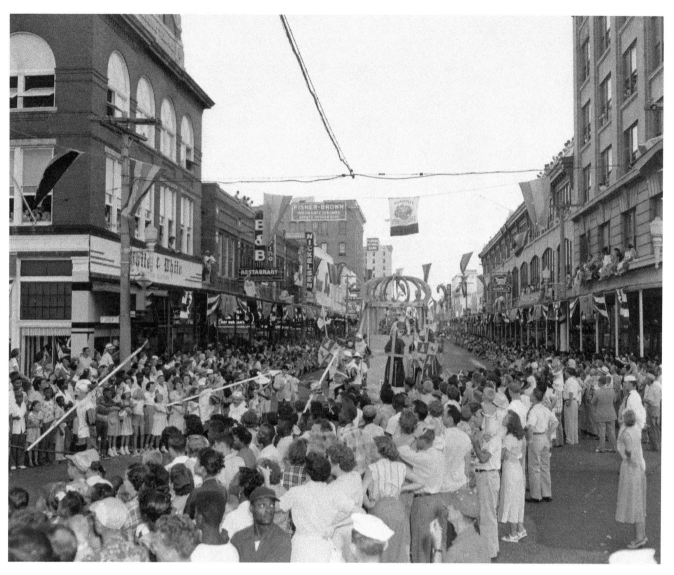

The 1954 Fiesta of Five Flags parade was the first local parade ever broadcast live to Pensacola homes. The scenes were sent from WEAR-TV cameras over Southern Bell Telephone Company lines to the central telephone office. The images were then beamed to the television station tower by way of microwaves.

The new Chemstrand plant brought high-paying jobs to the Pensacola area when it opened in Cantonment in 1953. The first U.S. plant licensed to produce nylon, by 1963 the Cantonment site was the world's largest producer of nylon. The plant has undergone two name changes over the years. Becoming the Monsanto Company in 1962, the plant introduced Astro Turf in 1966. After a division of the company in 1997, the plant was renamed Solutia.

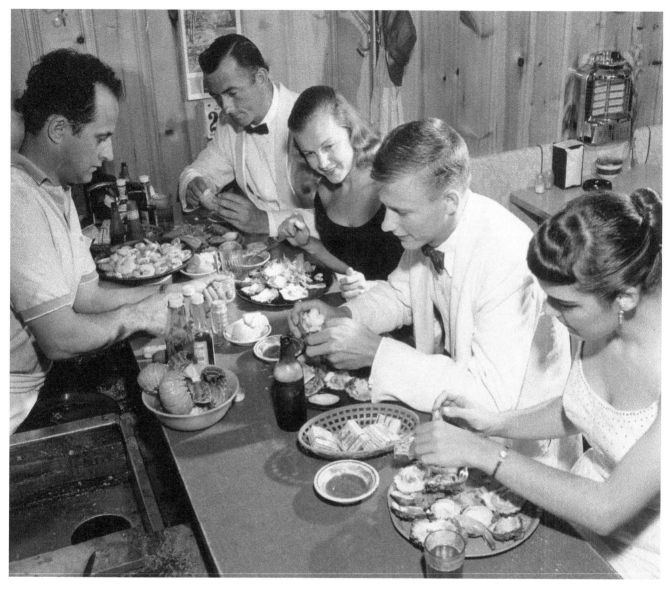

Raw bars have long been a favorite way to enjoy freshly shucked local oysters. This venue features the once-popular wall-mounted jukebox, an example of which is visible at upper-right.

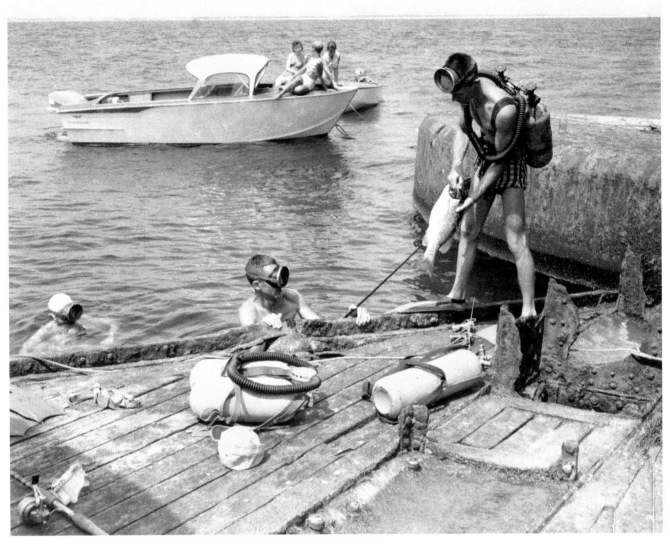

Scuba diving and spear fishing are popular area pastimes. These sportsmen were enjoying the fishing near the USS *Massachusetts*, which was sunk offshore after World War I and used for military target practice.

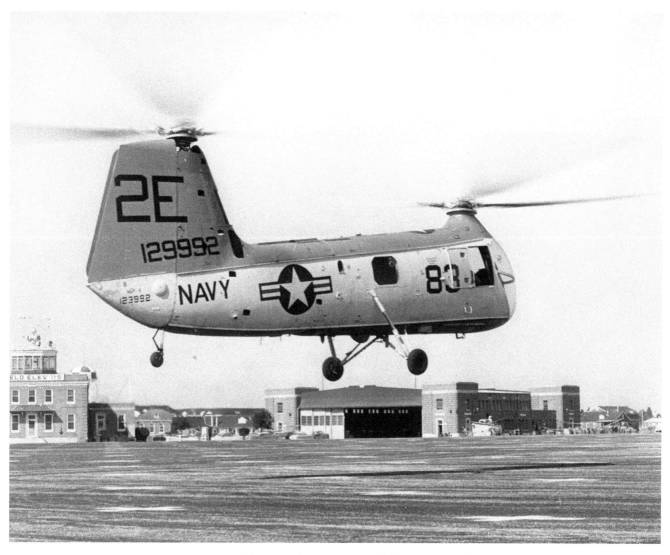

The Piasecki HUP was used for training naval pilots stationed in the Pensacola area.

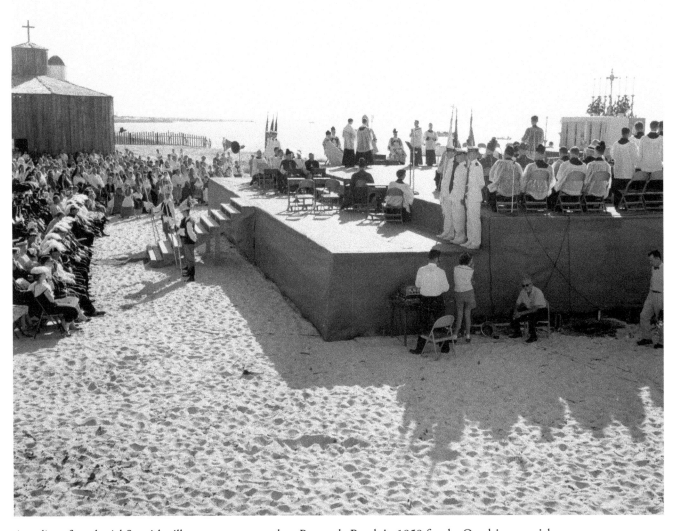

A replica of a colonial Spanish village was constructed on Pensacola Beach in 1959 for the Quadricentennial Festival, a celebration of the 400th anniversary of the first settlement of Pensacola. Archbishop Thomas J. Toolen of the Catholic Diocese of Mobile conducted consecration ceremonies of the village mission.

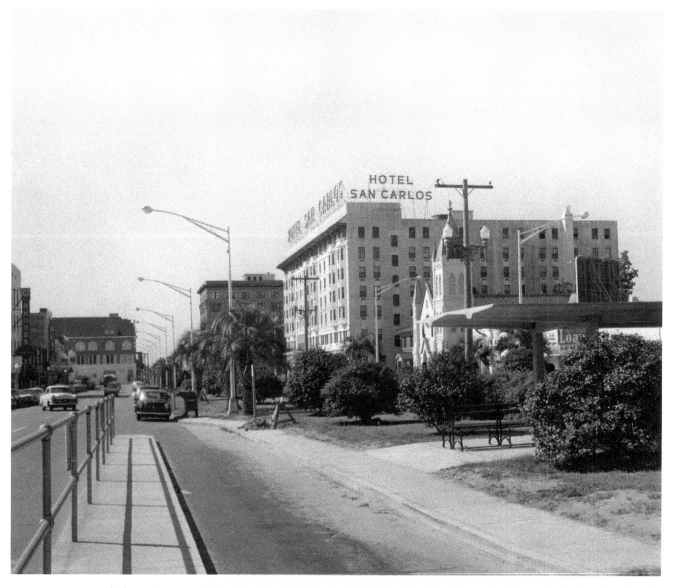

Sleek, modern streetlights line North Palafox in 1960. The Hotel San Carlos dominates the skyline, dwarfing St. Michael's Catholic Church and the Blount Building. An addition to the San Carlos closed the opening on the north end of the building.

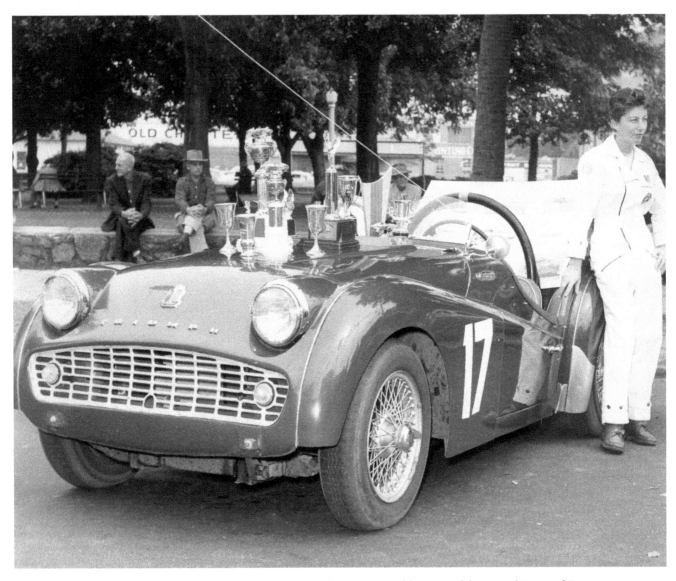

For many years, the Navy co-sponsored a national sports-car rally at Corry Field as part of the annual Fiesta of Five Flags. Ferraris, MGs, Jaguars, Triumphs, Austin-Healys, Mercedes, and Corvettes were some of the automobiles brought to the yearly event.

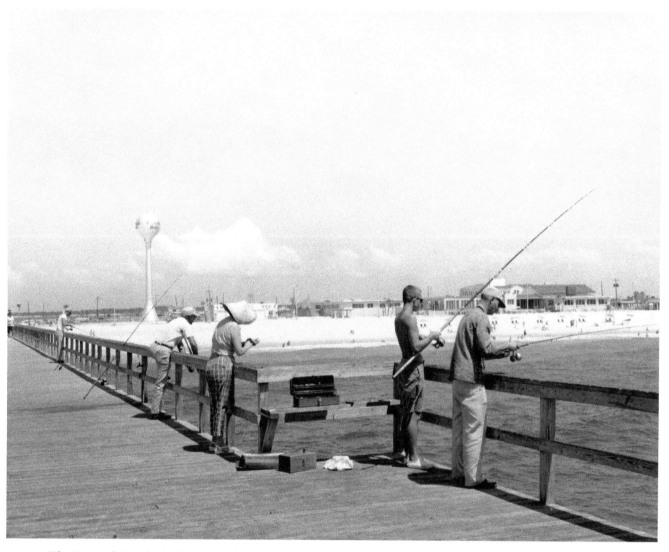

The Pensacola Beach pier has always been a popular place for anglers, offering them a chance to catch dinner as they enjoy the sun and water.

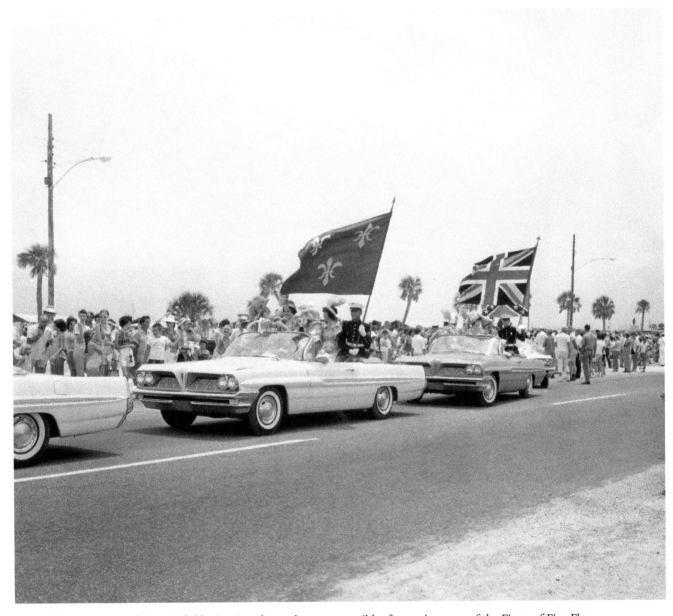

Vince Whibbs, owner of Vince Whibbs Pontiac, donated new convertibles for use in many of the Fiesta of Five Flags parades. Mr. Whibbs, known as the "Man of Integrity," was mayor of Pensacola from 1977 through 1991.

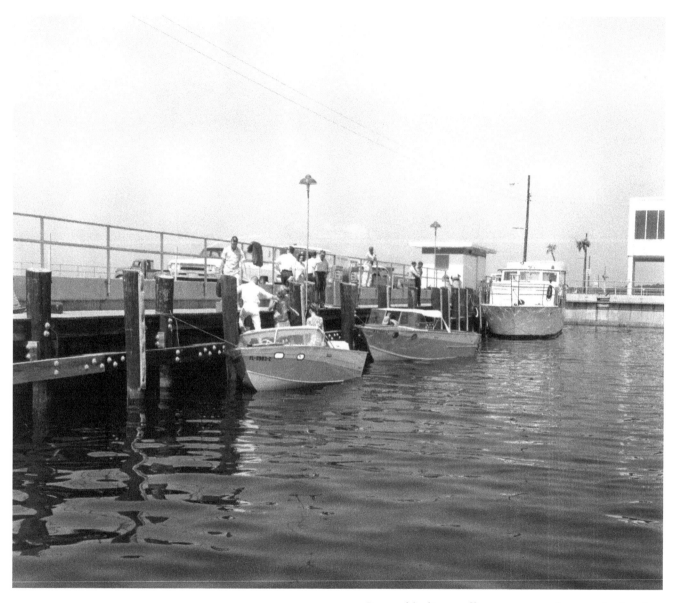

Pensacola's climate offers many warm days to enjoy boating.

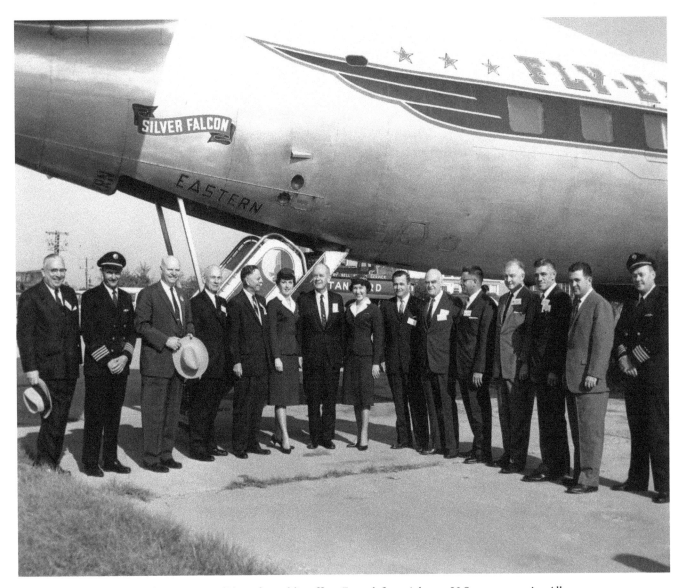

Pensacola was a stop in 1960 among candidates for public office. From left to right are U.S. representative Albert Herlong, Jr.; a pilot; U.S. representative Bob Sikes; Comptroller Ray E. Green; Superintendent of Public Instruction Thomas D. Bailey; a stewardess; gubernatorial candidate Farris Bryant; a stewardess; Agricultural Commission candidate Doyle Conner; Treasurer J. Edwin Larson; Secretary of State candidate Tom Adams; Attorney General Richard Ervin; Edwin L. Mason, campaigning for the Railroad and Public Utilities Commission; an unidentified man; and a pilot.

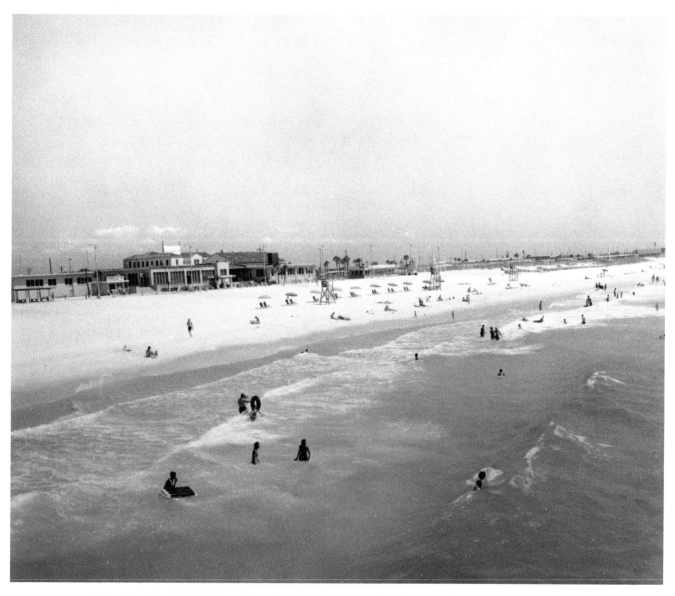

Casino Beach, with its lifeguards and amenities, continued to be a popular place to enjoy the sun and surf in 1960.

Notes on the Photographs

These notes, listed by page number, attempt to include all aspects known of the photographs. Each of the photographs is identified by the page number, a title or description, photographer and collection, archive, and call or box number when applicable. Although every attempt was made to collect all data, in some cases complete data may have been unavailable due to the age and condition of some of the photographs and records.

II **Chipley Monument**
Florida State Archives
Rc18956

VI **Blue Angels**
Florida State Archives
c035981b

X **Confederate Soldiers**
Florida State Archives
Rc02582

2 **9th Mississippi**
Florida State Archives
Rc02504

3 **Confederates**
Florida State Archives
Rc04842

4 **Navy Yard**
Florida State Archives
Rc05101

5 **Bayou Grande**
Florida State Archives
Rc02503

6 **Cannon Balls**
Florida State Archives
Rc07482

7 **Union Troops**
Florida State Archives
N030769

8 **Base Housing**
Florida State Archives
N030770

9 **Downtown**
Florida State Archives
Rc18960

10 **Variety Store**
Florida State Archives
Rc03094

11 **Business District**
Florida State Archives
Rc04783

12 **Cadets**
Florida State Archives
Rc06181

13 **Brent Brothers**
Florida State Archives
Rc19204

14 **Rebuilding**
Florida State Archives
Rc04785

15 **Customs House**
Florida State Archives
Rc06378

16 **Saunders Company**
Florida State Archives
Rc06179

17 **Fire Department**
Florida State Archives
Rc06214

18 **Courthouse**
Florida State Archives
Rc03193

19 **Methodist Church**
Florida State Archives
PR08490

20 **South Palafox**
Florida State Archives
Pr08399

21 **Masons Building**
Florida State Archives
Rc00-16

22 OLD CHRIST CHURCH
Florida State Archives
Rc06369

23 GARFIELD GUARDS
Florida State Archives
PR00848

24 GENERAL CHASE HOME
Florida State Archives
Rc19200

25 FIRST NATIONAL BANK
Florida State Archives
Rc07631

26 LUMBER COMPANY
Florida State Archives
N036808

27 FIRE CONTROL SYSTEM
Florida State Archives
Rc06370

28 BATHHOUSE PIER
Florida State Archives
Rc06216

29 FIRE CONTROL TOWERS
Florida State Archives
Rc06371

30 CENTER AVENUE
Florida State Archives
Rc18995

32 DEEP-WATER PORT
Florida State Archives
Rc18965

33 PROFESSIONAL FIREMEN
Florida State Archives
PR08439

34 PALAFOX STREET PIER
Florida State Archives
N036800

35 SPANISH CHURCH
Florida State Archives
Rc06099

36 FLOODED STREETS
Florida State Archives
Rc12633

37 EAST MAIN STREET
Florida State Archives
Rc17084

38 HURRICANE OF 1906
Florida State Archives
Rc18964

39 SHIPWRECKED
Florida State Archives
Rc17085

40 CONSOLIDATED GROCERY
Florida State Archives
Rc19199

41 STRIKEBREAKERS
Florida State Archives
PR08429

42 TROLLEY STRIKE
Florida State Archives
Rc01670

43 STRIKE CAMPS
Florida State Archives
Rc01671

44 MILITIA
Florida State Archives
N036917

45 STRIKEBREAKERS
Florida State Archives
Rc01672

46 BRICK WALL
Florida State Archives
Rc19201

47 JUNIOR HIGH SCHOOL
Florida State Archives
PR08442

48 FIRE COMPANY #4
Florida State Archives
Rc04781

49 METHODIST EPISCOPAL
Florida State Archives
Rc18976

50 BANK BUILDING
Florida State Archives
Rc06231

51 CROSSING SOUTH PALAFOX
Florida State Archives
Rc06202

52 BIG PARADE
Florida State Archives
Rc04720

84 **VINCENT VIDAL**
Florida State Archives
ms25739

85 **WIDE MEDIAN**
Florida State Archives
Rc06183

86 **ROUNDHOUSE**
Florida State Archives
Rc12963

87 **MOTHER-IN-LAW**
Florida State Archives
ms25749

88 **CITY HALL**
Florida State Archives
Rc191892

89 **GARCIA BECK**
Florida State Archives
ms25988

90 **CORRY FIELD**
Florida State Archives
PR08410

91 **GOVERNOR SHOLTZ**
Florida State Archives
N036819

92 **USS PENSACOLA**
Florida State Archives
Rc20024

93 **STUDENTS**
Florida State Archives
PR08424

94 **MOBILE SAWMILL**
Florida State Archives
N032399

95 **FERA DOCK BUILDERS**
Florida State Archives
N036796

96 **BAYVIEW PARK**
Florida State Archives
PR08470

97 **MATTRESS FACTORY**
Florida State Archives
N034701

98 **BATHHOUSES**
Florida State Archives
N036851

99 **ADULT EDUCATION**
Florida State Archives
PR00818

100 **PENSACOLA BEACH**
Florida State Archives
N036805

102 **WAR EFFORT**
Florida State Archives
Rc24106

103 **PENSACOLA BEACH**
Florida State Archives
c005439

104 **CASINO BEACH**
Florida State Archives
c006062

105 **MOVIE LINES**
Florida State Archives
c007738

106 **DOWNTOWN**
Florida State Archives
c010591

107 **HOTEL SAN CARLOS**
Florida State Archives
c007402

108 **WATCHING THE RACE**
Florida State Archives
c010682b2

109 **HIGH SCHOOL BAND**
Florida State Archives
GV010758

110 **RIBBON CUTTING**
Florida State Archives
GV035080

111 **PENSACOLA BEACH BRIDGE**
Florida State Archives
PR15066

112 **DEDICATION CEREMONY**
Florida State Archives
PR15067

113 **ENJOYING THE SUN**
Florida State Archives
c0135502

114 **LIFEGUARD**
Florida State Archives
c013192

115 **FIESTA OF FIVE FLAGS**
Florida State Archives
c014995

116 **MISS AMERICA**
Florida State Archives
c014992

Printed in the USA
CPSIA information can be obtained
at www.ICGtesting.com
JSHW072022140824
68134JS00042B/3744